D1267025

FEDERICO ZERI (Rome, 1921-1998), eminent art historian and critic, was vice-president of the National Council for Cultural and Environmental Treasures from 1993. Member of the Académie des Beaux-Arts in Paris, he was decorated with the Legion of Honor by the French government. Author of numerous artistic and literary publications; among the most well-known: *Pittura e controriforma*, the Catalogue of Italian Painters in the Metropolitan Museum of New York and the Walters Gallery of Baltimora, and the book *Confesso che ho sbagliato*.

Work edited by FEDERICO ZERI

Text
based on the interviews between
FEDERICO ZERI and MARCO DOLCETTA

This edition is published for North America in 2000 by NDE Publishing*

Chief Editor of 2000 English Language Edition
ELENA MAZOUR (*NDE Publishing**)

English Translation
SUSAN SCOTT

Realization
ULTREYA, MILAN

Editing
LAURA CHIARA COLOMBO, ULTREYA, MILAN

Desktop Publishing
ELISA GHIOTTO

ISBN 1-55321-023-9

Illustration references

Bridgeman/Alinari Archives: 16-17, 24b, 27a, 30, 32a, 32-33, 41, 42b, 45/I-XI-XII.

Giraudon/Alinari Archives: 1, 2-3, 4a, 5, 6-7, 7, 8-9, 9, 10-11, 11, 13a, 16a-b, 20-21, 23b, 24a, 25a-b, 36-36b-37, 38-39, 39a, 40a, 43, 44/VI-VII-X-XI, 45/II-IV-VII-XIV.

Luisa Ricciarini Agency: 2, 19, 28a, 32b, 36a, 40b, 44/IX.

RCS Libri Archives: 3a, 12b, 13b, 15, 22-23, 23a, 28-29, 39b, 44/VIII-XII, 45/III-X.

R.D.: 4b, 12a, 14a-b, 16c, 18, 26-27, 27b, 28b, 31, 34-35, 35a-b, 42a, 44/I-II-III-IV-V, 45/V-VI-IX-XII, 46-47.

Printed and bound by Poligrafici Calderara S.p.A., Bologna, Italy

* *a registered business style of NDE Canada Corp.*
15-30 Wertheim Court, Richmond Hill, Ontario
L4B 1B9 Canada, tel. (905) 731-1288

The captions of the paintings contained in this volume include, beyond just the title of the work, the dating and location. In the cases where this data is missing, we are dealing with works of uncertain dating, or whose current whereabouts are not known. The titles of the works of the artist to whom this volume is dedicated are in blue and those of other artists are in red.

POUSSIN

THE TRIUMPH OF FLORA

In THE TRIUMPH OF FLORA, Poussin presents a grand, sweeping composition of themes taken from Ovid's *Metamorphoses*. The master of French Classicism presents a parade of demigods moving

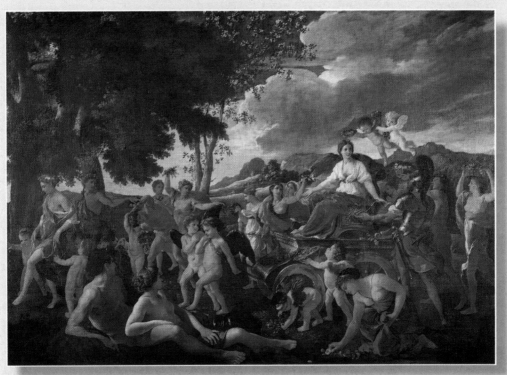

along elegantly against a luxuriant natural background. The various mythological figures thus become in some way attributes of Flora.

THOROUGH STUDY OF THE MYTH

THE TRIUMPH OF FLORA

c. 1627

● Paris, Louvre (oil on canvas, 165x241 cm)

● The canvas was painted around 1627, on a commission from Cardinal Sacchetti, who later ceded it to Cardinal Omodei; in 1684 it came into the collection of Louis XIV. In all probability, Cardinal Sacchetti hung it as a *pendant* to *The Triumph of Bacchus* (1628) by Pietro da Cortona (1596-1669).

● Urged by the poet Giambattista Marino to come to Rome, and introduced by him to Cardinal Sacchetti and Cardinal Francesco Barberini, Nicolas Poussin soon achieved fame in a city where artistic competition was fierce.

● His life was marked by suffering and renunciation, both personal and artistic. His youthful ardor and vocation for painting were stifled by his own decisions, which led him to eschew social acclaim and the honors of the European courts. Often ill, he chose to lead a modest life, marrying in 1630 the young daughter of a pastry chef, Anne Marie Dughet, and preferring to paint small canvases destined for a rich, discriminating clientele rather than large commissions. Nonetheless he was in great demand, respected and courted by Richelieu, Louis XIII, and Bernini.

● Poussin subjected his art to the control of his intellect, carefully calculating its measure and reining in the impulse of intuition. His profound study led to the sacrifice of immediate lyricism in favor of a deliberate search for the right tone to express his theme.

◆ SELF-PORTRAIT (1650, Paris, Louvre, detail). Born in Normandy in 1594, Poussin died in Rome in 1655; in 1641 he was named first court painter to King Louis XIII.

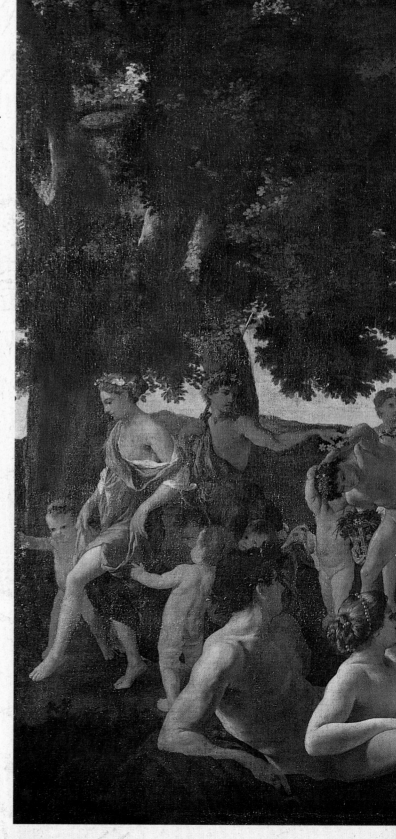

◆ THE TRIUMPHS

The pronounced colorism of Poussin's early works places him in a direct line with the painting style of Titian (c. 1490-1576), as do some of his themes. As an academic exercise, Poussin copied numerous works by Titian and was familiar with his dense *impasto*; he had also studied and made many drawings of antique sculpture, both reliefs and free-standing. Both experiences contributed equally to his expressing, in a compositional texture unprecedented in the Rome of that day, the sensuous vitality exuded by the painting. In a later version of *The Kingdom of Flora* (1631, Dresden, Staatliche Kunstsammlungen, right), space is treated as a cube, marked off by vertical elements which impart a greater harmony to the whole.

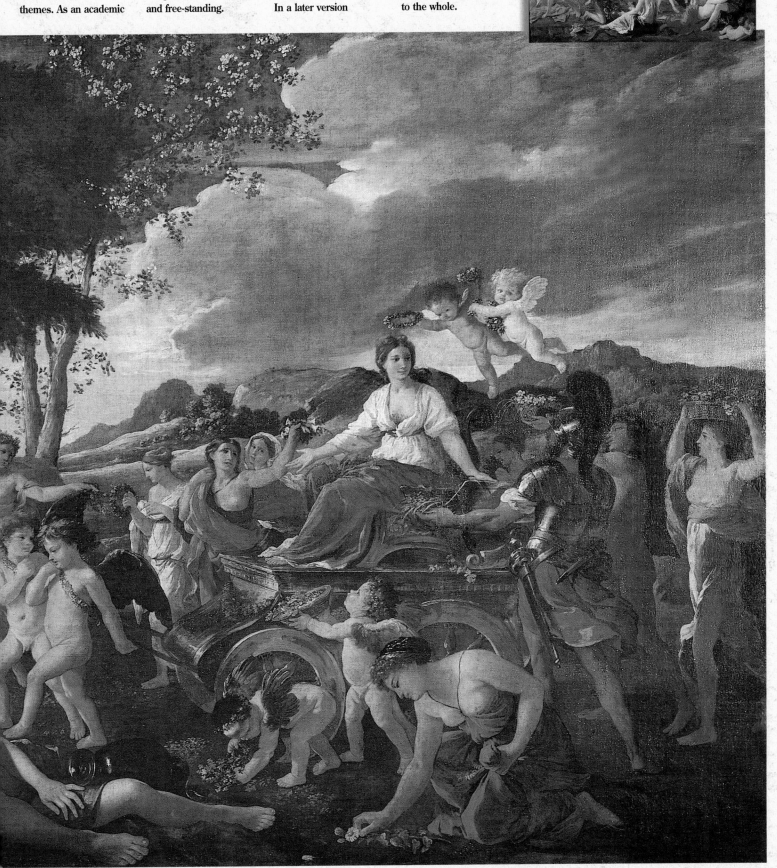

RECOUNTING TALES OF LONG AGO

Poussin's earliest works contained the germ of the aesthetic he would develop later; his was a meditation on the equilibrium of feelings and the very human and mythical nobility of the heart, base for an intellectual adventure, in which it's hard to know whether to admire more his aesthetic solutions or the intensity of their underlying concept.

● The air of dawn which permeates all of Poussin's paintings seems, in the majestic, crystalline scene of *The Triumph of Flora*, to allude to some hypothetical early time of mankind, presented through the filter of mythological archetypes. Among rivers, forests, and cavorting putti, the artist recreates the fables of King Midas, Acis and Galatea, the childhood of Bacchus, but also the stories of Rebecca at the well, Moses in the bulrushes, the flight into Egypt.

● *The Triumph of Flora* is Poussin's first approach to a theme which he would treat again in *The Kingdom of Flora* (1631) and in a series of *Bacchanals* painted for the Château de Poitou, commissioned by Cardinal Richelieu. He includes in Flora's train demigods connected with the birth of flowers: the great warrior Ajax, the nymphs Clytia and Smilax, Narcissus, Hyacinth, Apollo's inseparable friend, and Adonis, drawing for their myths on Ovid's *Metamorphoses*. The lyrical beauty of the composition evokes an ideal world where all is grace and light. But, through the experiences of the figures inhabiting it, love and beauty lay their foundation in the suffering and torment which they themselves produce.

● Poussin's study of Titian's large paintings, from Ferrara and at that point in Rome in the Ludovisi and Aldobrandini collections, resonates particularly in the figures of the cherubs. Two contemporary copies of this painting survive, one in the Pinacoteca Capitolina, the other in a private collection in the Marches.

◆ THE MEETING OF BACCHUS AND ARIADNE (1626, Madrid, Prado). In this painting, the multitude of personages is not yet well coordinated, as is the case in the later *Triumph of Flora*; while the individual figures do not suffer, the overall harmony is compromised. The very large canvas teems with characters, and the complexity of the subject suggests that it was painted as a commission.

◆ FLORA AND AJAX A mute dialogue takes place between Flora, the ancient Sabine goddess of spring, seated on a chariot and crowned by cherubs, and Ajax, the son of Telamon. Flora, with the hint of a smile, looks toward the valorous hero who, unable to live with the shame of his madness, killed himself. From his blood on the ground sprang forth a flower similar to the hyacinth.

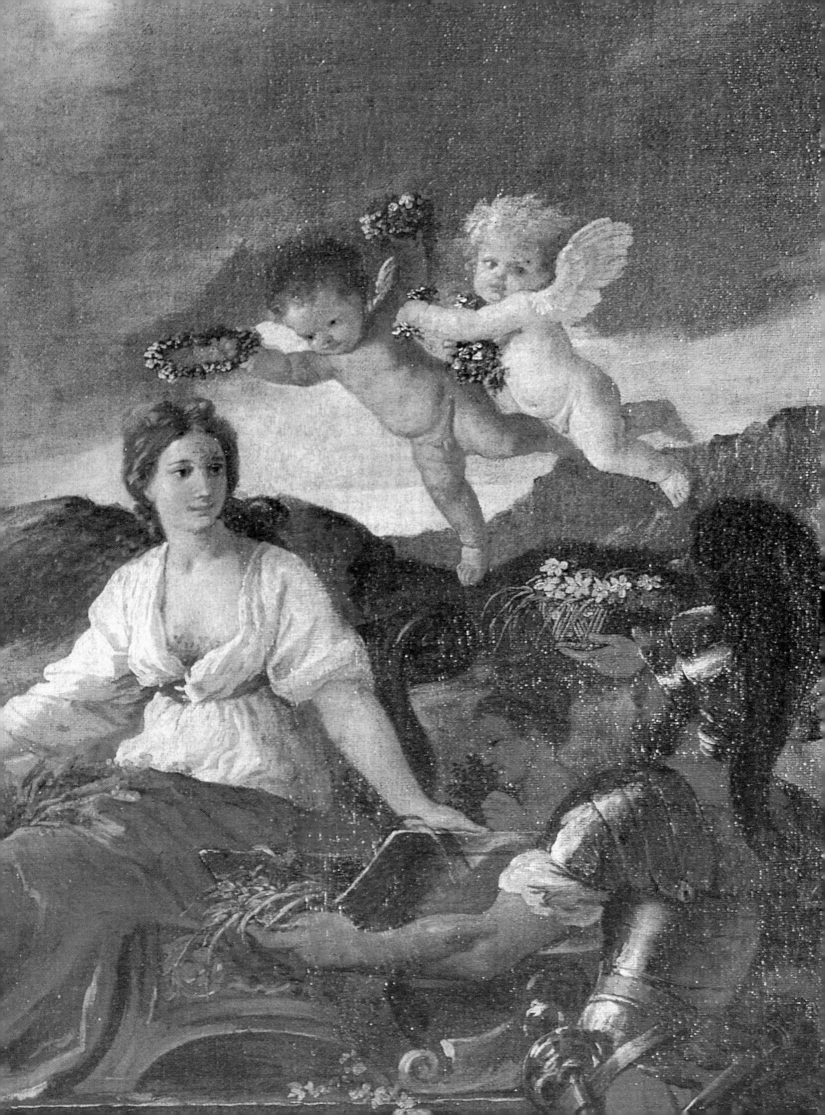

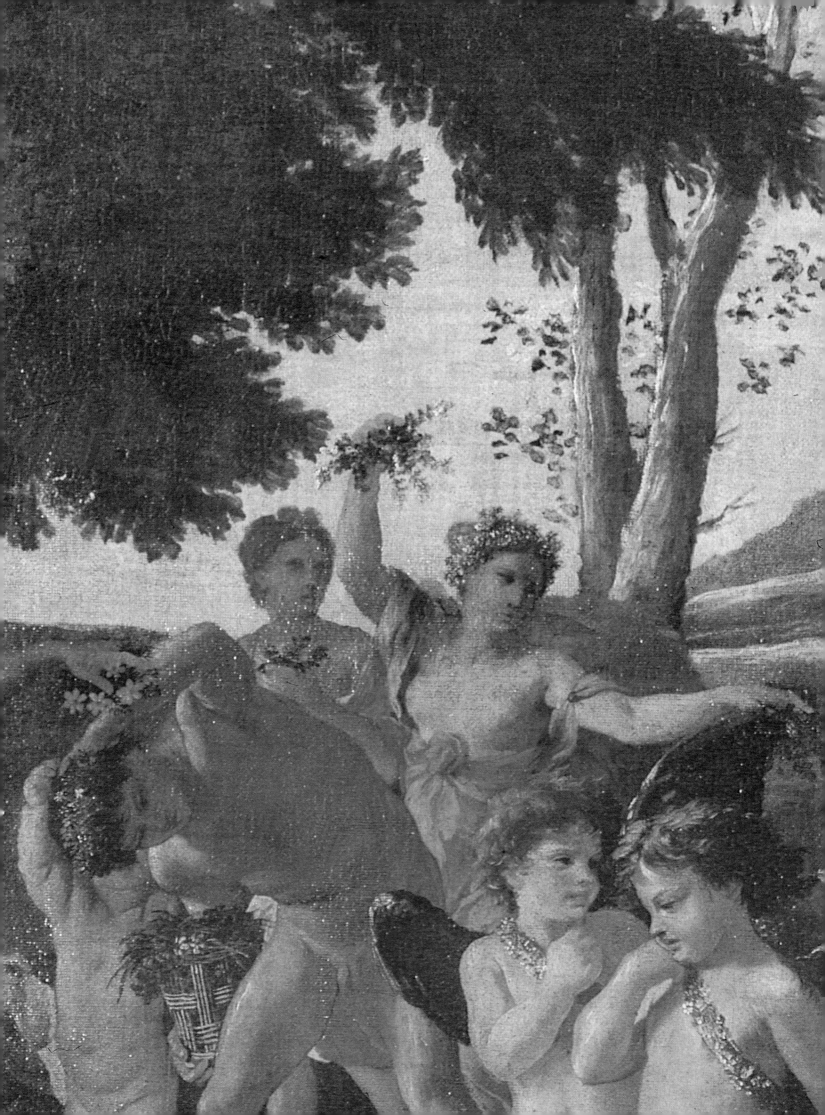

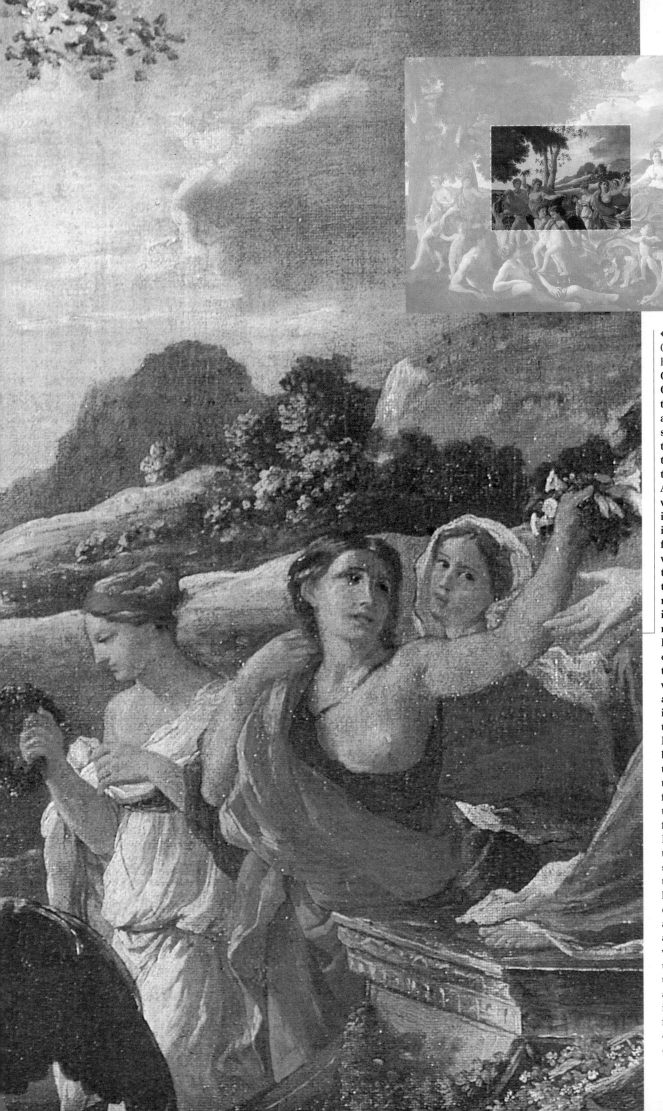

◆ BEAUTY GENERATED BY PAIN

Once again Ovid gives a hand to art with a mythological story of transformation, to explain the origin of the hyacinth. According to a version well known in the ancient world, it was not the blood falling from Ajax's wound which generated the flower, but the death of a young man, Apollo's inseparable friend, named Hyacinth. He and the god were competing one day throwing the discus, when he was accidentally struck in the head by the discus thrown by Apollo. He was killed by the blow, and the unconsolable god, to immortalize his friend's name, made the flower spring forth from his blood. In the painting, the young man is shown leaning forward, touching his head with his left hand. A host of nymphs dances around the chariot; among them is Smilax, who because of an unhappy love was transformed into a prickly vine. Beauty is thus born of pain, from the suffering caused by a love that ends tragically.

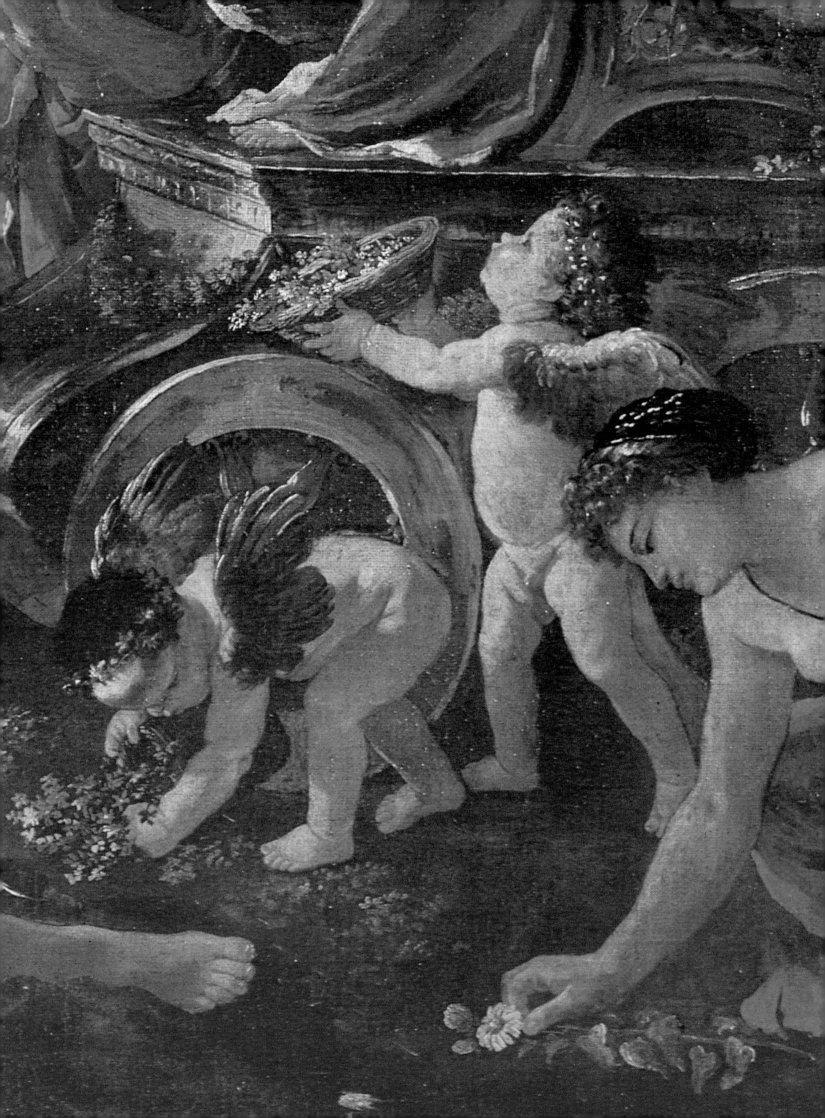

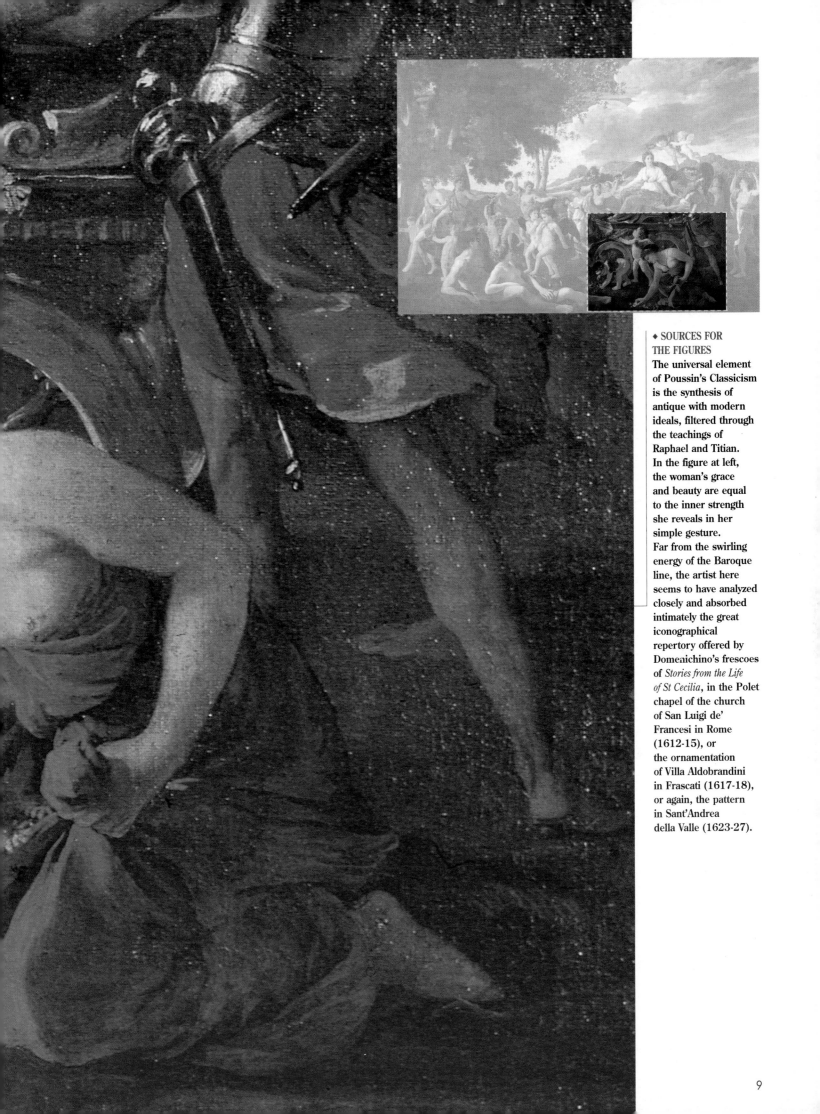

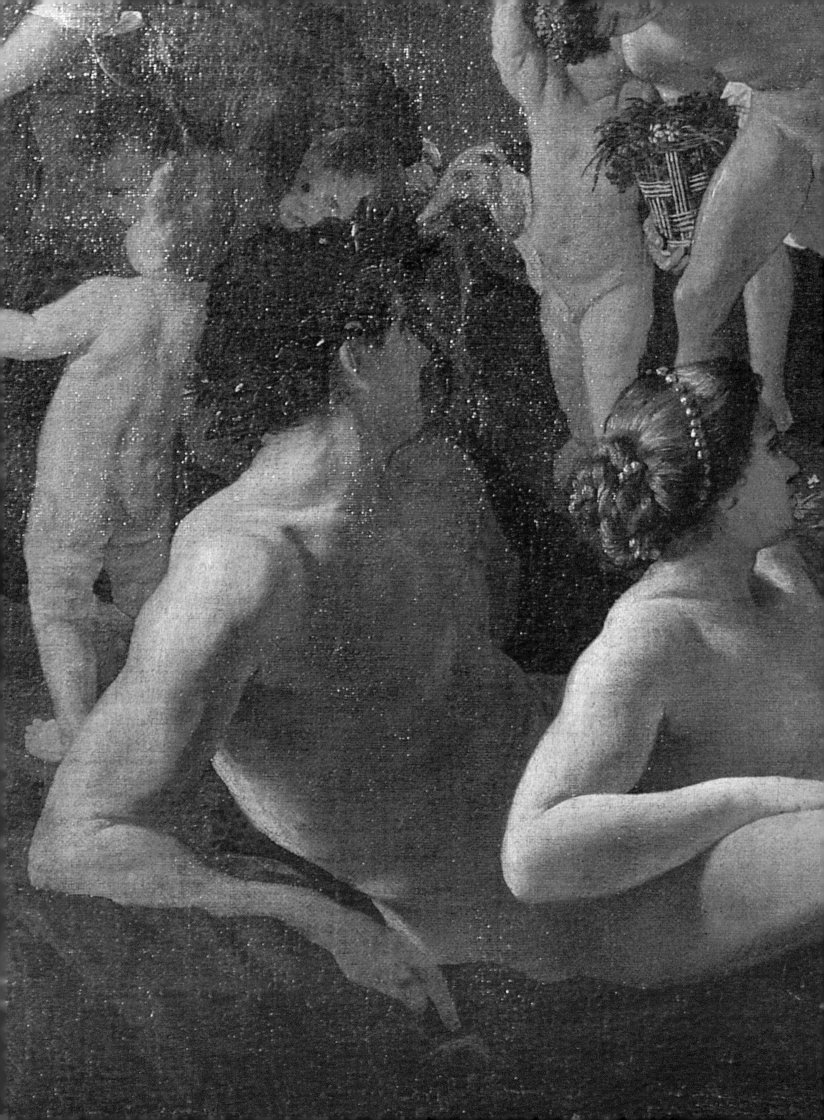

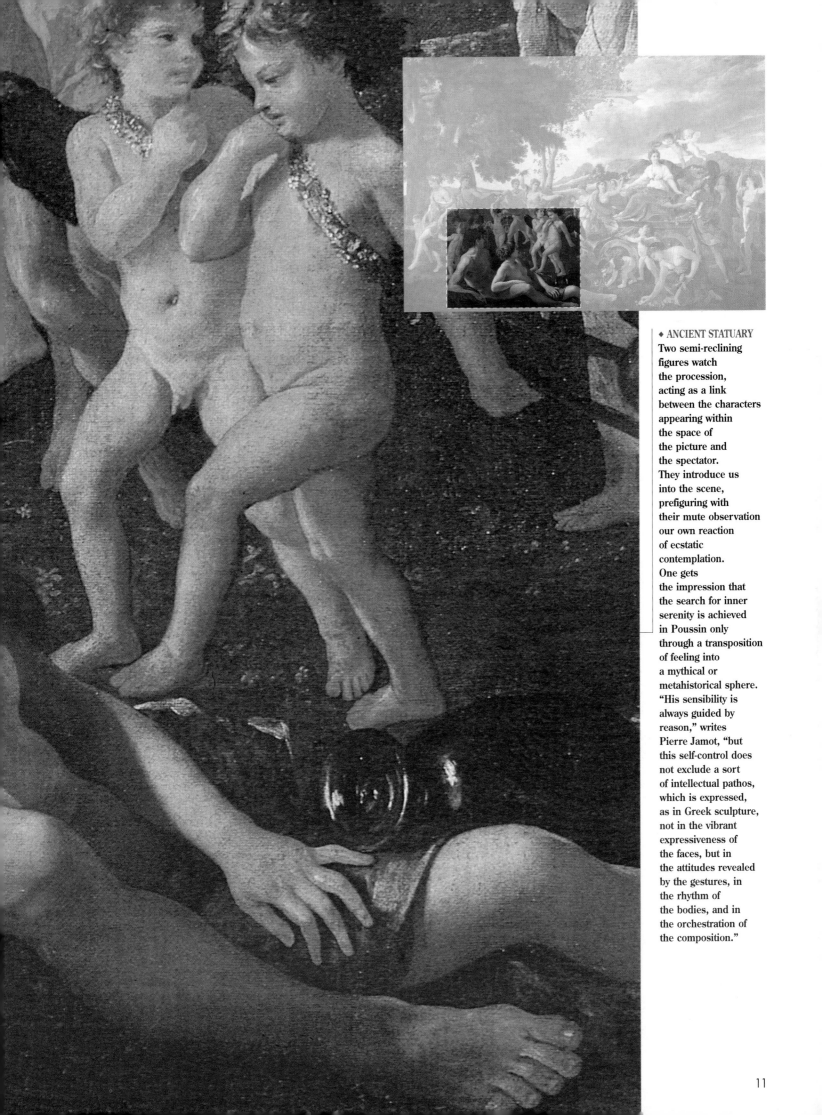

♦ ANCIENT STATUARY
Two semi-reclining
figures watch
the procession,
acting as a link
between the characters
appearing within
the space of
the picture and
the spectator.
They introduce us
into the scene,
prefiguring with
their mute observation
our own reaction
of ecstatic
contemplation.
One gets
the impression that
the search for inner
serenity is achieved
in Poussin only
through a transposition
of feeling into
a mythical or
metahistorical sphere.
"His sensibility is
always guided by
reason," writes
Pierre Jamot, "but
this self-control does
not exclude a sort
of intellectual pathos,
which is expressed,
as in Greek sculpture,
not in the vibrant
expressiveness of
the faces, but in
the attitudes revealed
by the gestures, in
the rhythm of
the bodies, and in
the orchestration of
the composition."

THE MASTER OF FRENCH CLASSICISM

Nicolas Poussin fully achieved the aims of eighteenth-century Classicism, translating into compositions of high dignity and solemnity permeated by a profound moral sense, the aesthetic ideas expressed from the earliest years of the century in Roman artistic circles and already being adopted, with varying intents and results, by Annibale Carracci (1560-1609), Guido Reni (1575-1642) and Domenichino (1581-1641).

● Attracted by the classical world, he studied it thoroughly, developing his own extensive, sensitive knowledge of the myths and rites of antiquity. For Poussin, the classical world was one that he felt to be distant and for just this reason more beautiful and inviting, even if its serene harmony was, in the end, so similar to death that he could not look at it except with deep melancholy.

● Poussin viewed history as a closed dimension, in which every-

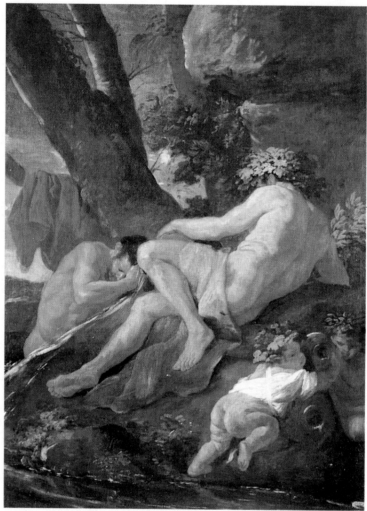

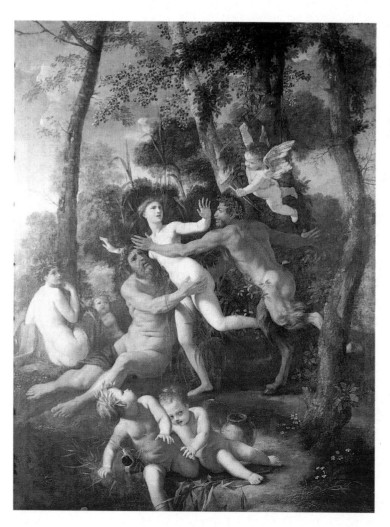

thing is "beautiful" because nothing can be changed by present contingencies; for him the human condition implies almost a sense of waiting, comforted by the certainty that the future will in turn become the past. History is for Poussin the instant blocked for eternity by memory in the form of the monument.

● For him, the sense of monumentality takes on a universal expression, utilizing the typical formula for the "monumental" in art: allegory. This is not necessarily presented with an imposing theatrical effect: the measured movements, solemn, grave gestures, even the limpid, measured landscape have no need of large dimensions. The persuasive force of Poussin's paintings lies precisely in their balance between the clarity of Cartesian rationality and the explosive, mysterious power of nature, of infinity.

◆ MOSES IN
THE BULRUSHES
(1638, Paris, Louvre).
The destiny of the great
leader of Israel is
contained in his
salvation from
the waters of the Nile.
Pharaoh's daughter
takes compassion
on him and adopts
him, calling
him Moses, "drawn
from the water."

◆ MIDAS AT
THE SOURCE OF
THE RIVER PACTOLUS
(c. 1626, New York,
Metropolitan
Museum of Art).
This is a rather
unusual subject
and might have
fascinated Poussin
for its ethical
implications.
A meditation on human
destiny is accompanied
by reflection on
the granting of wishes.

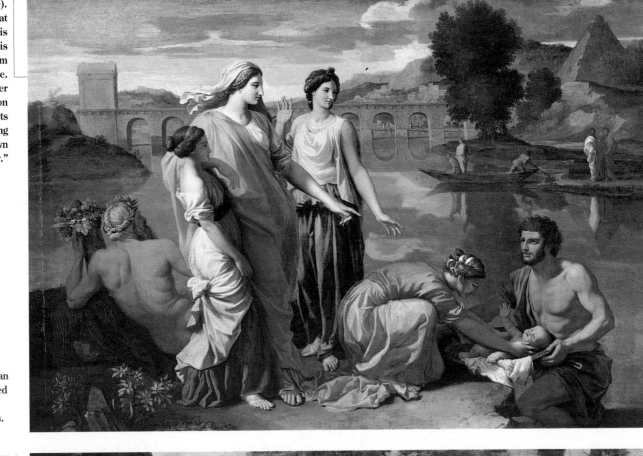

◆ MOSES STRIKING
THE ROCK
(1633-35, Edinburgh,
National Gallery
of Scotland).
Another extraordinary
version of the same
Bible story is in
the Hermitage in
St Petersburg. Poussin
returns often to
the stories of Moses
and their teachings on
salvation, achieved
through the sufferings
of the Hebrew people.

◆ PAN AND SYRINX
(1637, Dresden,
Staatliche
Kunstsammlungen).
Ovid's *Metamorphoses*
offer an unquenchable
source of artistic ideas
for one who, like
Poussin, was familiar
with the treatment
of myth. Here
the nymph is
transformed first into
a reed and then into
a musical instrument.

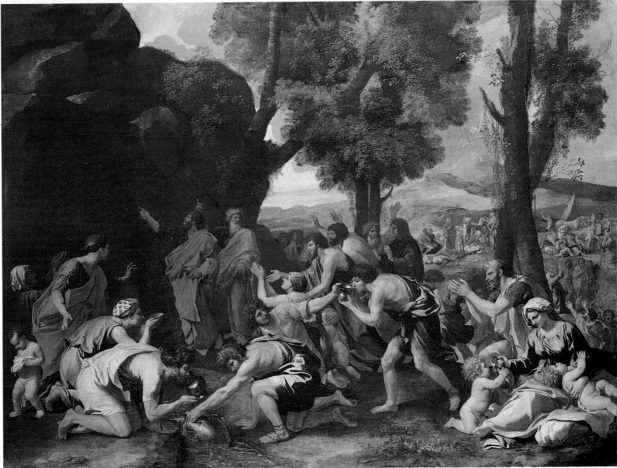

THOUGHT TRANSLATED INTO FORMS

After an early education in Paris, in which he became acquainted, through engravings and drawings, with the work of Italian artists, Poussin revealed a precocious desire to go to Rome, but his plans were upset more than once by health problems or unexpected commitments.

● Only after becoming friends with Giambattista Marino, present from 1615 at the court of Paris, Poussin's dream began to take shape. The Italian poet, seeking a good painter to "illustrate some stories" encouraged the artist to make some drawings of episodes from his own poem *Adonis*, Ovid's *Metamorphoses*, Livy's *Histories*, and Virgil's *Aeneid*, introducing him to a taste for mythology and the history of ancient Rome.

● Toward the end of 1623, Poussin, finishing up some commitments in Paris, left for Italy, where Marino had already returned in April to reside in Rome. He first spent a short period in Venice, where he studied the masterpieces of sixteenth century Venetian art, particularly Titian. Passing through Bologna (where he had already been on another trip to Rome, cut short in Tuscany because of health problems), he was able to study the art of the Carracci family and Guido Reni, whose investigation of Classicism he soon took up with renewed vigor.

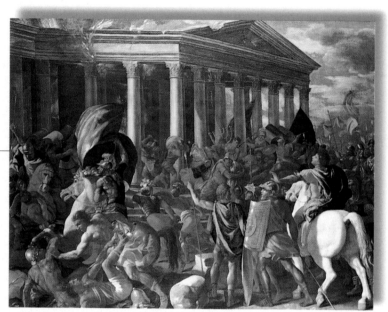

◆ THE SACK OF THE TEMPLE OF JERUSALEM BY TITUS'S TROOPS (1625-26, London, Hazlitt, Gooden & Fox). The canvas was restored to Poussin's catalogue in 1995 by Denis Mahon. The whereabouts had been lost of this valuable witness to Poussin's first Roman period, as the work had passed through many hands, starting with Cardinal Barberini who gave it to Richelieu as a gift.

● Poussin's first Roman works reflect his memories of French Mannerist culture of the second School of Fontainebleau (1594-1610), which reworked themes used by Rosso Fiorentino (1495-1540) and Primaticcio (1504-70), of his youthful studies from prints and from antiquity, of the "Roman" drawings of Giulio Romano (c. 1499-1546), and the compositions of Reni (1575-1642) and Domenichino (1581-1641). But the predominant element in this complex artistic culture was Titian's colorism.

◆ THE ARCADIAN SHEPHERDS (ET IN ARCADIA EGO) (1628-29, Chatsworth, Duke of Devonshire collection). In the foreground is a river god; Poussin treats the nude in such detail here for the first time. Other solidly constructed figures read the inscription, "Et in Arcadia Ego," a reminder of the fleeting nature of happiness.

◆ VENUS AND ADONIS (1624-25, Fort Worth, Kimbell Art Museum). *Adonis* (1623) by Giambattista Marino, Poussin's friend, and the *Metamorphoses* (X, 529 ff.) are the literary sources inspiring the painter here to narrate a happy moment in the love story between the handsome young Adonis and the goddess. The atmosphere of happiness is reinforced by the serene expression of the cherubs.

● For some time, the experience of Poussin converged with the positions of Pietro da Cortona and Lanfranco (1582-1647), rising stars of the Baroque, leading him to create masterpieces like *The Death of Germanicus* and *The Martyrdom of St Erasmus*. His friendship with the classicist Andrea Sacchi (1599-1661) and the Flemish sculptor François Duquesnoy (1597-1643) marked his increasing detachment from Baroque schemes and the return to an ideal of harmonious classical composure, which would prove better suited to the expression of his reflections on the uselessness of desire.

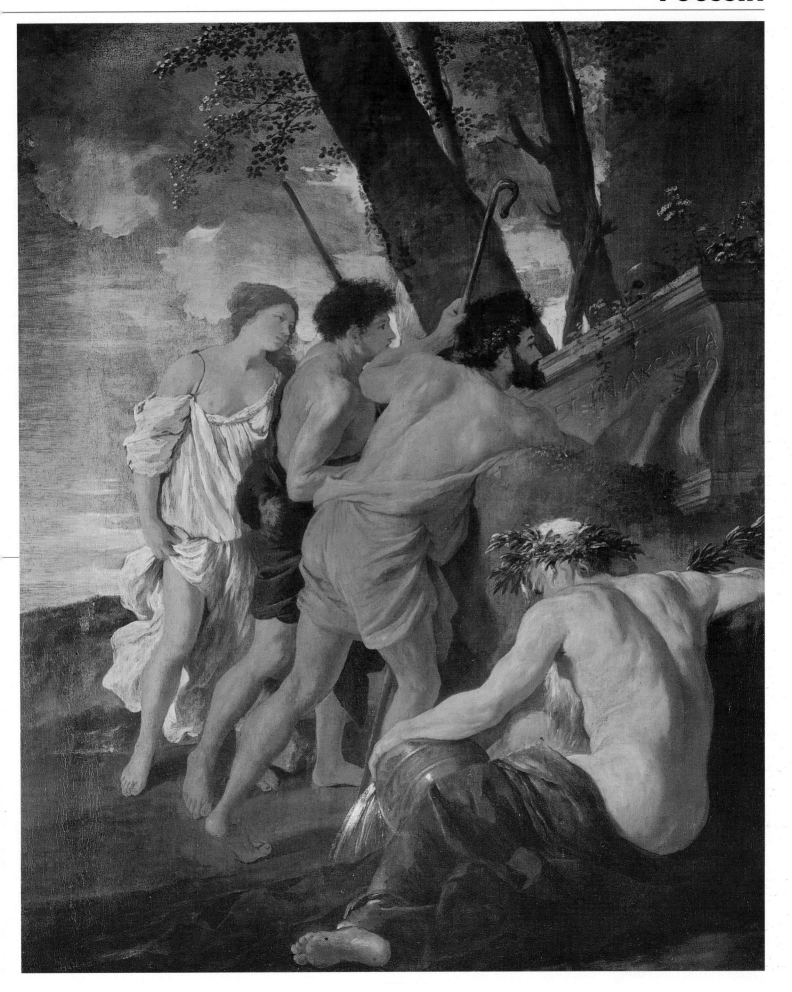

◆ THE DEATH OF GERMANICUS
(1626-28, Minneapolis, Institute of Arts).
The episode is taken from the *Annals* by Tacitus. At their commander's deathbed, next to the grieving Agrippina, his officers swear to avenge him. The epic tone is combined with the ethical theme, in an attempt to portray the affections.

◆ JOSHUA FIGHTING THE AMELIKITES
(1625, St Petersburg, Hermitage).
The influence of Lanfranco, who was working in the church of San Giovanni dei Fiorentini, is clear in the strong contrast of light. *Joshua Fighting the Amorites*, now in the Pushkin Museum in Moscow, is its *pendant*.

◆ THE TRIUMPH OF A POET
(c. 1625, Rome, Galleria Nazionale d'Arte Antica).
The poet's resemblance to Marino suggests that the painting may have been made in his honor, perhaps on the occasion of his death (March 25, 1625). Attribution to Poussin is not unanimous.

◆ LANDSCAPE WITH NUMA POMPILIUS AND THE NYMPH EGERIA
(1628-30, Chantilly, Musée Condé).
The canvas, which shows distinct compositional analogies with the *Landscape with the Contest between Apollo and Marsyas* (1626), was perhaps commissioned by marquis Cassiano dal Pozzo.

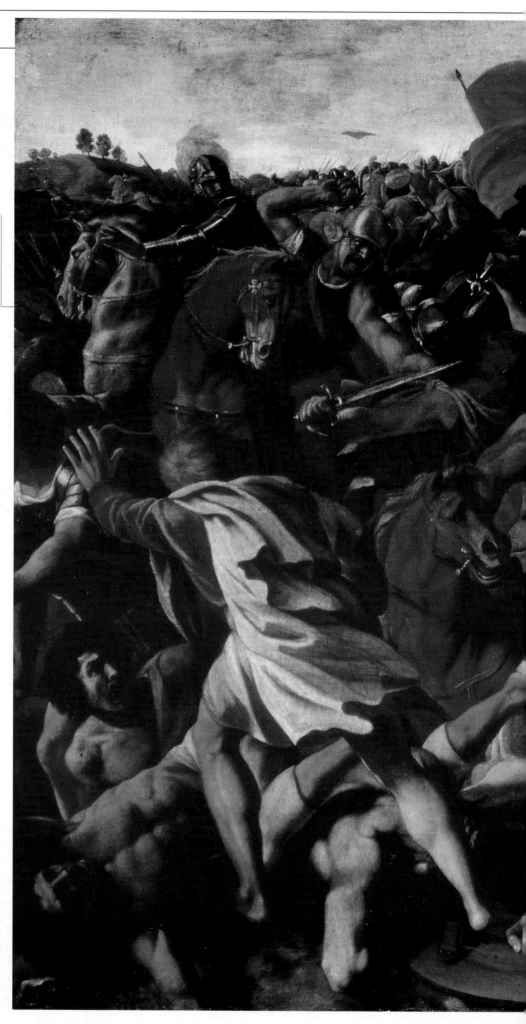

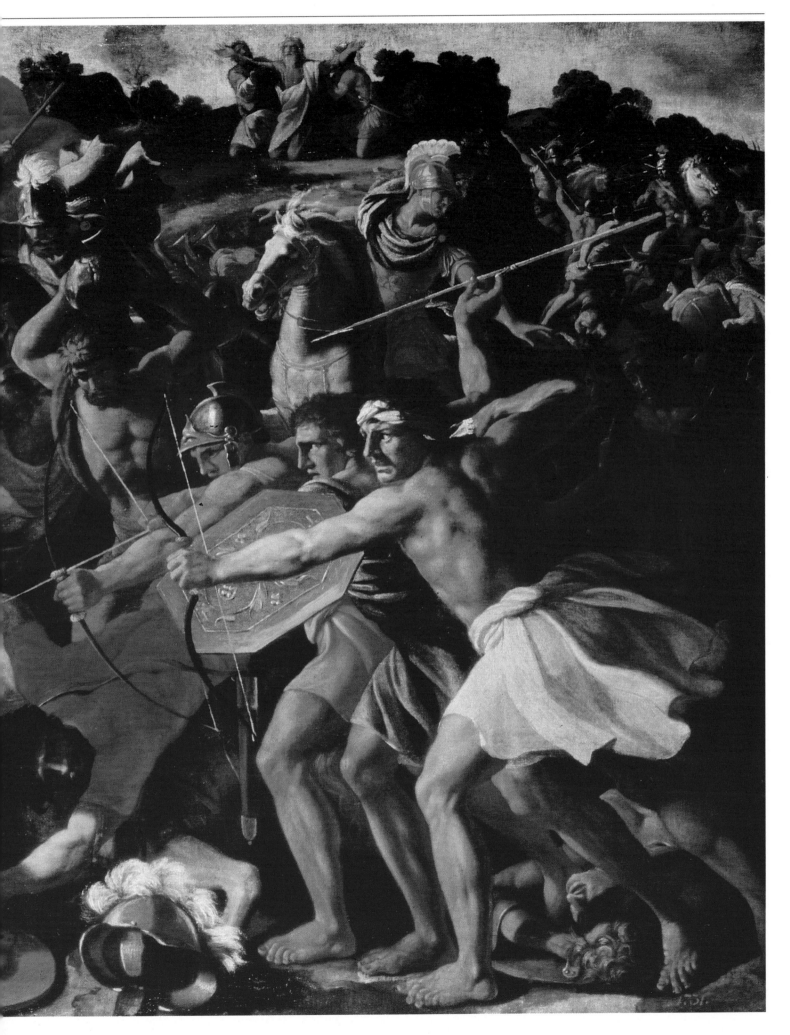

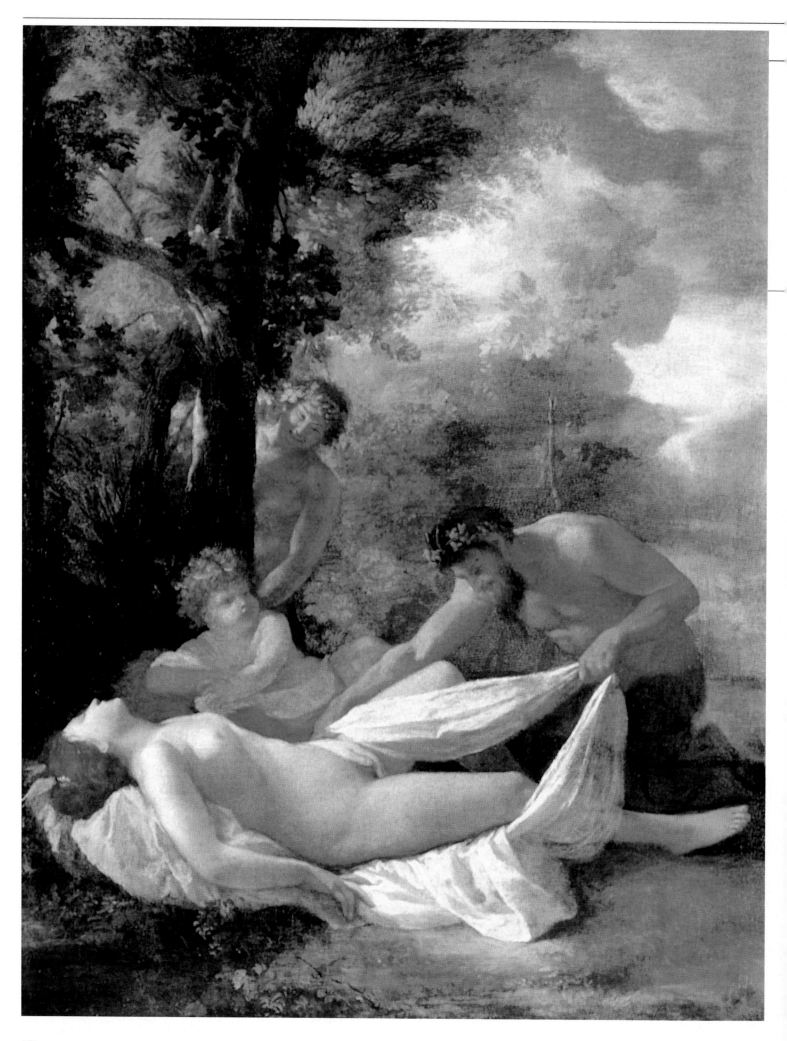

◆ SLEEPING NYMPH
WITH SATYRS
(1626-27, London,
National Gallery).
Presented
as an original
work by Denis
Mahon in 1999,
in the exhibition
devoted to Poussin's
first Roman period,
the canvas presents
a subject the artist
treated many times
in easel paintings,
which were easily sold.
The production
of paintings for sale,
while on one hand
frees the artist to
choose his subject,
on the other imposes
a genre: landscape,
erotic fable, battle
scene, etc.
It thus falls
to the patron
to orient the artist's
decision in
the direction
of current taste.

◆ THE MARTYRDOM
OF ST ERASMUS
(1628-29, Rome,
Pinacoteca Vaticana).
Thanks to the support
of Gian Lorenzo
Bernini (1598-1680),
Poussin painted this
altarpiece for
St Peter's, taking over
from Pietro da
Cortona. The artist was
now at the top
of the Roman cultural
scene, and the public
destination
of the painting
confirms this.
The martyrdom is seen
as a cruel, sadistic
murder which takes
place, by contrast,
in a dazzling light.
The winch on which
the saint's intestines
are being wound is
a detail of raw
naturalism, balanced
by the serene classical
form of a statue of
Hercules presiding
from his Olympian
distance over
the conquest
of immortality
through martyrdom.

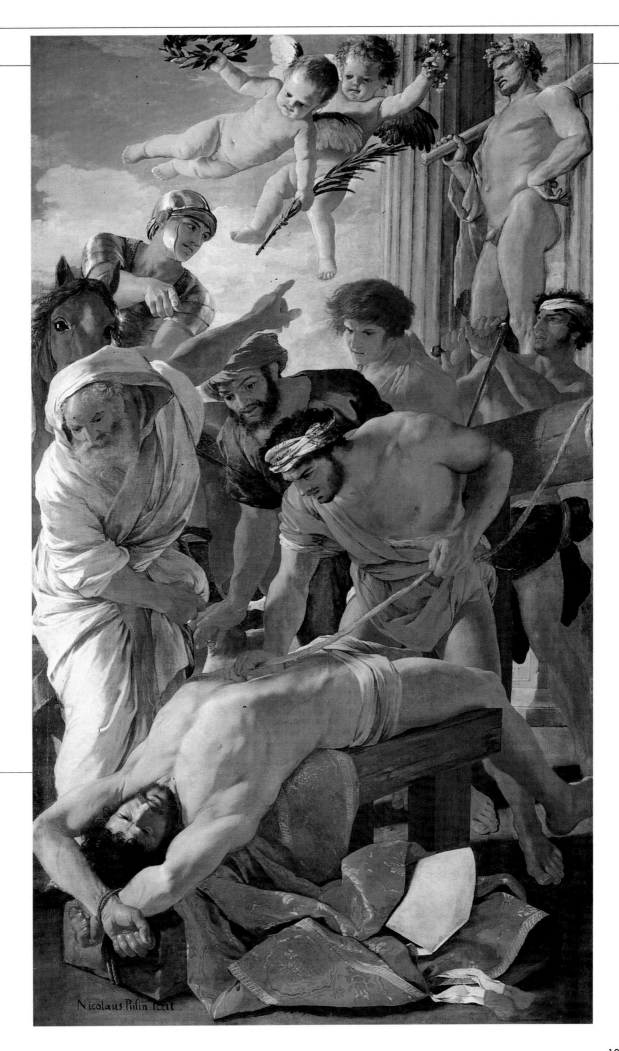

THE SERENE HARMONY OF HISTORY

The debate on the primacy of color or drawing, between Classical and Baroque, ancient and modern, occupied the artists of the Academy of St Luke in the years 1636-37. The two positions were taken, on one side, by the Baroque of Pietro da Cortona, and on the other by the restrained Classicism of Poussin.

● The French artist viewed classical culture not only as a formal model, but as the foundation of experience on which to build an ethic at the same time profoundly Christian and nonconformist. Poussin found in the ancient world the utopian dimension of *pietas*, properly confined within the sphere of myth; for this reason, his pictures are inhabited almost exclusively by creatures who approach each other lovingly, naturally sharing in a state of well-being, following the example set by Titian in the large mythological paintings of his youth.

● Classicism is not a norm or a stock of historical forms offered to artists for study and imitation; it is opposed in equal measure to realism, rule, and whimsy, and offers itself as a principle of order, understood not as a rigid hierarchy but as natural order. In this sense, then, lies the proper interpretation of Poussin's statement: "My nature makes me seek and love well-ordered things, fleeing from confusion which is as much my enemy as the light is the enemy of darkness." In the sphere of things, order is Nature, in that of human action it is History; thus, the classical ideal for Poussin is historical action set in a "natural" space and time.

● Around the fourth decade, the artist was oriented towards a compositional scheme capable of conferring the greatest dignity and decorum on his scenes of history, whether sacred or profane, following the models worked out by Raphael and mediated through the Emilian masters. In his paintings from this period we first find symmetrical structures, which later become more complex in depth as well, as though to rebut the accusations of compositional inadequacy made by Baroque artists. The conception of the picture as a stage, understood as a way of measuring vision, was Poussin's new area of investigation, as he moved from the Baroque epic toward a Classicism derived from Palladio (1508-80) and Serlio (1475-1554/5), through the mediation of Domenichino.

◆ THE TRIUMPH OF PAN (1634-37, Paris, Louvre). The painting belongs to the series of four canvases called the *Bacchanals* and commissioned by Cardinal Richelieu to decorate his chateau at Poitou. All the sources agree that there were three "ground" *Bacchanals* and a "sea" one: *The Triumph of Pan*, *The Triumph of Bacchus*, *The Triumph of Silenus*, and *The Triumph of Neptune*. The question is quite complex, both for the dating and for establishing which paintings are original, as at the time various copies were made of a very high quality. There is an identical version of this painting in the National Gallery in London. As for the date, a document from 1636 refers to a transfer of ownership of two *Bacchanals* from Cardinal Richelieu to the bishop of Albi. It is therefore presumed that the entire series must have been completed around that year.

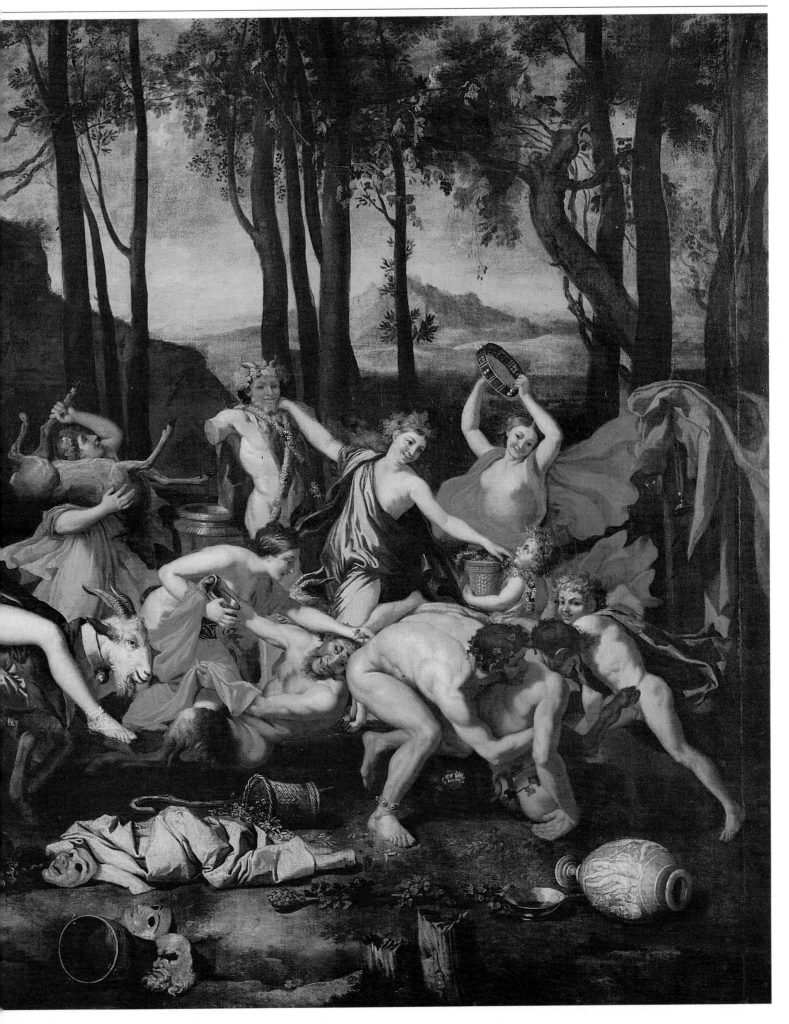

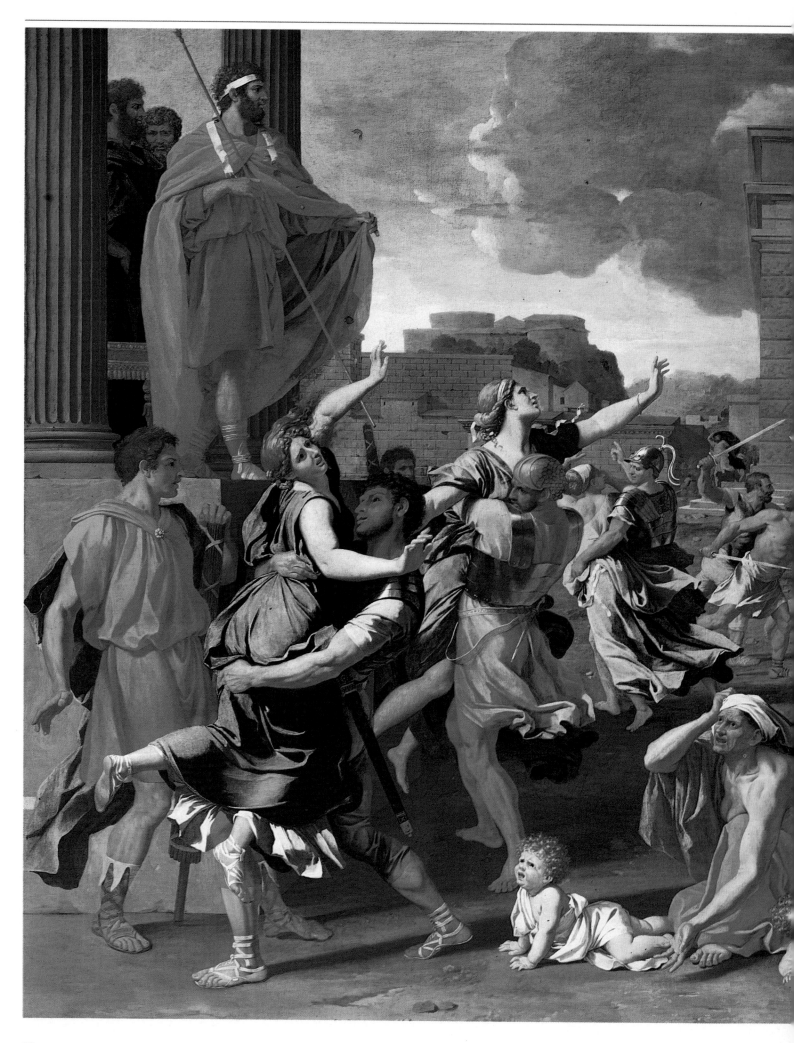

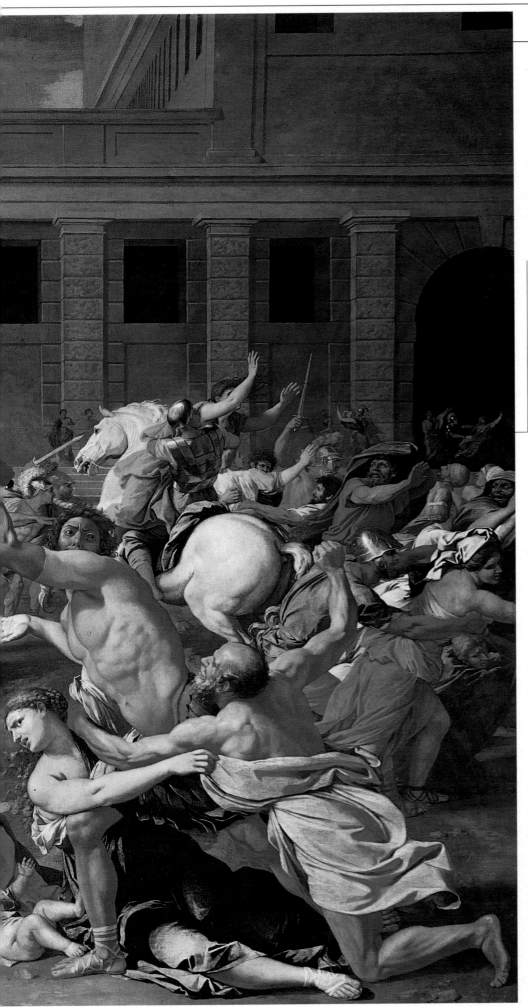

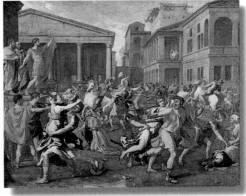

◆ **THE RAPE
OF THE SABINES**
(c. 1634, New York,
Metropolitan
Museum of Art).
A meditation on fate
and the instruments
it uses to fulfill human
destiny underlies this
extraordinary work,
inspired by one
of the most famous
episodes of early
Roman history, narrated
by Livy in his *Historiae*.
Another version
(above) of *The Rape
of the Sabines,* now in
the Louvre and a large
canvas like this one,
was painted a few years
later (1637-38) and is
closer in setting to
*The Conquest
of Jerusalem* in Vienna.

◆ **SAINT MARGARET**
(1638-39, Turin,
Galleria Sabauda).
The fact that
the painting has
always been in
the Savoy family
has suggested
the hypothesis
that it was
commissioned
by Cassiano
dal Pozzo's cousin
Amedeo, Marquis
of Voghera. Because
of its large size, it is
thought to be
an altarpiece. The saint
is shown with a dragon,
the disguise used by
the devil, according
to her legend, which
she was able
to defeat using
a piece of a crucifix.

◆ THE PLAGUE OF AZOTH (1630-31, Paris, Louvre). The plague which struck Milan and a large part of northern Italy in 1630 may have given Poussin the idea that this Bible story would have been a topical one and thus easily sold. In fact, it was immediately bought by the Sicilian aristocrat Fabrizio Valguarnera who, while the canvas was still being painted by the artist, ordered a copy of it – now in London – from the painter Angelo Caroselli. Thanks to this copy, we know that Poussin changed the architectural background of the original after the copy had already been finished.

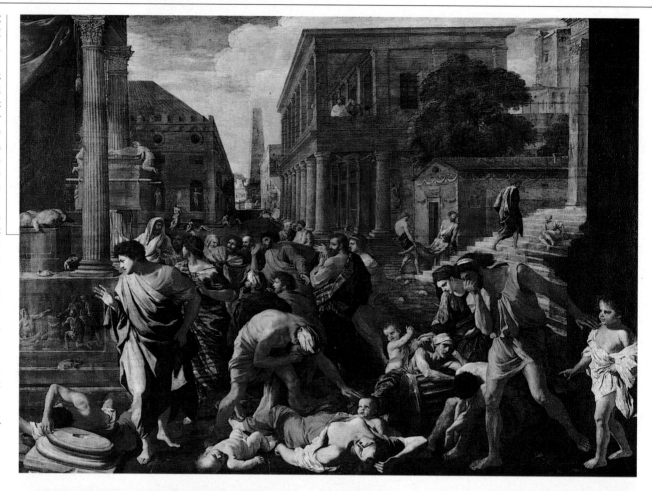

◆ PARNASSUS (1631-35, Madrid, Prado). Apollo and the nine Muses gather around the Castalian spring, whose water transmits to those who drink it the passion for and gift of poetry. On either side of the central group are the greatest poets of antiquity, identifiable by their laurel wreaths. The theme, already magnificently illustrated by Raphael in the Stanza della Segnatura in the Vatican, was a particular favorite of Classicist painters and those of the School of Fontainebleau, whom Poussin had studied intensely during his youth in the galleries of the royal palace.

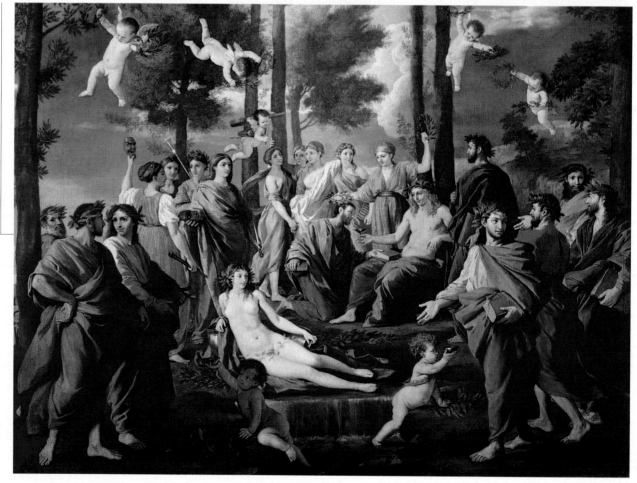

◆ THESEUS FINDING HIS FATHER'S SWORD (1633-34, Chantilly, Musée Condé). The episode from Greek mythology is narrated by Plutarch, Diodorus, and Iginus. Aegeus, Theseus's father, after coupling with Aethra, hid his sword and sandals under a rock and told her that, if a son should be born of their union, she should send him to Athens as soon as he was able to lift the heavy stone. This was done, and after many adventures the young man reached Athens, where he was recognized by his father and named heir to his throne. Some critics maintain that the architectural backdrop is the work of Pierre Lemaire.

◆ THE FALL OF MANNA (1637-38, Paris, Louvre). The painting was made for his friend Fréart de Chantelou between 1637 and 1638. In Paris, it passed into the hands of the superintendent Fouquet and from him to Louis XIV. The Bible story is one of the stories of Moses (*Exodus* 16:14 ff), from which Poussin often drew inspiration for the high moral content of their teachings. The subject was painted in that same period also by Rubens (1577-1640) and Giovan Francesco Romanelli (1610-62), a painter in the circle of Pietro da Cortona, an indication of the public's appreciation of meditations on the insatiable nature of human passions.

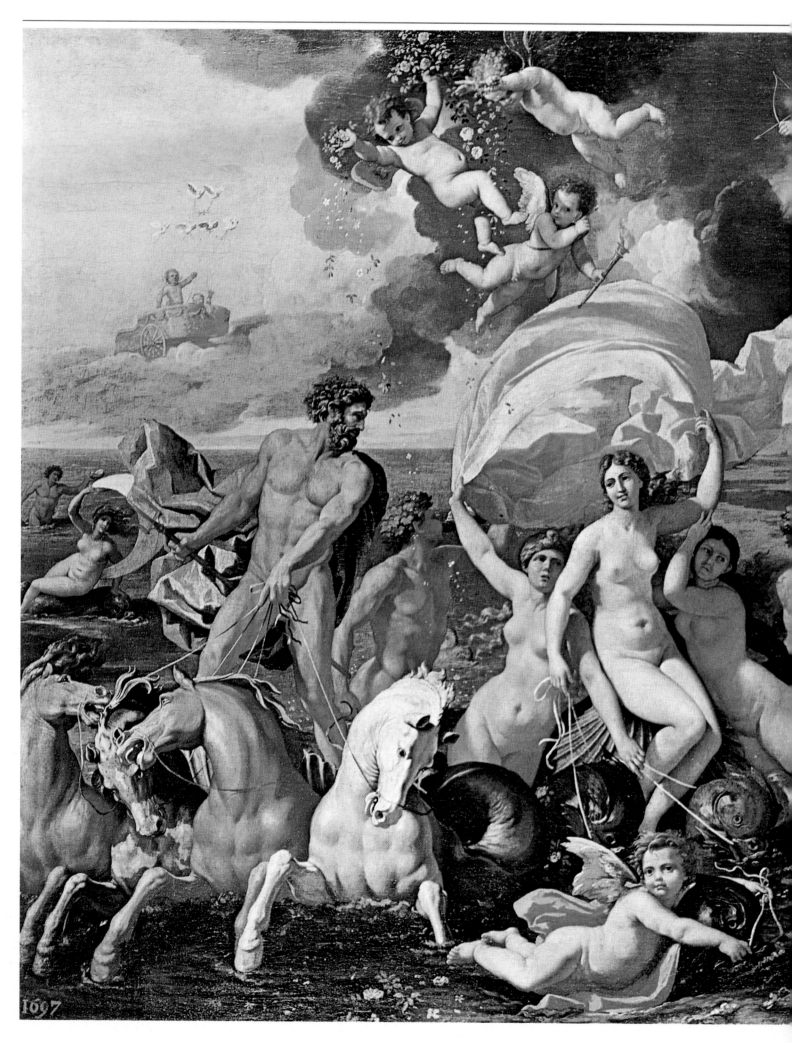

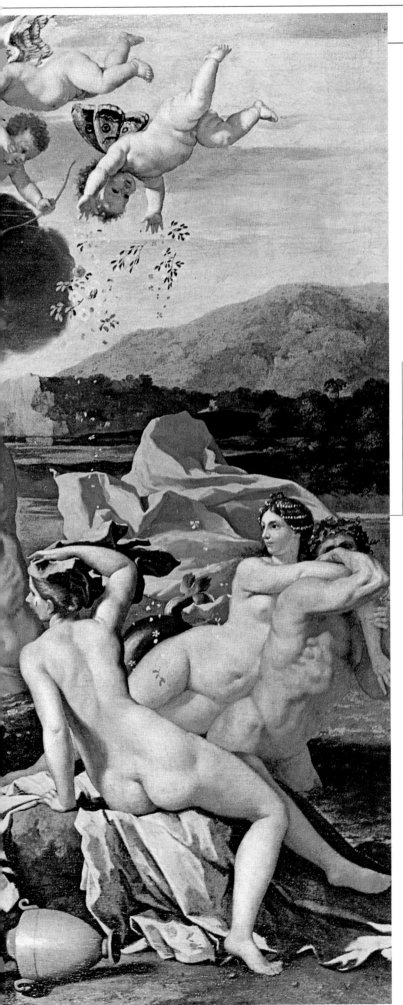

◆ THE TRIUMPH
OF NEPTUNE
(1634-37),
Philadelphia,
Philadelphia
Museum of Art).
Neptune rides the crest
of the waves with his
team of horses, with
Venus close behind him
in her shell-shaped
chariot, accompanied
by Nereids and Tritons.
The painting is part of
Richelieu's series
of *Bacchanals*.
The decision to include
a marine triumph
along with the terrestrial
ones is probably
a reference to the role
attributed to Richelieu
of restorer of
the French navy.

◆ THE SEVEN
SACRAMENTS:
EXTREME UNCTION
(1636-40, Belvoir
Castle, Rutland
collection).
Poussin responded
to the vast decorative
series of Pietro da
Cortona, besides
the *Bacchanals*, with
a series of paintings
centering on
the institution of
the sacraments,
commissioned by
Cassiano dal Pozzo.
The first canvas
to be painted was
Extreme Unction,
while *Confession*, known
from an engraving
by Dughet, was
destroyed by fire.

◆ THE SEVEN
SACRAMENTS:
CONFIRMATION
(1636-40,
Belvoir Castle,
Rutland collection).
To the imperious,
agitated line of Baroque
painting, Poussin
opposes a slow,
harmonious cadence.
The starkness of the
settings, inspired by
Roman architecture,
and the measured,
solemn movements of
the characters impart an
air of stoical gravity to
the sacred subject,
marking an important
point of reference for
the future development
of history painting up to
Jacques-Louis David.

◆ THE CONQUEST
OF JERUSALEM
(1638, Vienna,
Kunsthistorisches
Museum).
Poussin had already
dealt with this theme,
inspired by the *Bellum
Judaicum* by Flavius
Josephus, in his first
Roman period.
This time, the painting
was commissioned
by Cardinal Francesco
Barberini, as a gift
to Prince Eggenberg,
imperial ambassador
at the court of Pope
Urban VIII. The battle
rages in front
of the Temple, while
in the background
the city is already being
subjected to sacking
and slaughter.

◆ VENUS GIVING
AENEAS HIS WEAPONS
(1639, Rouen, Musée
des Beaux-Arts).
The episode was
directly inspired
by some lines
from Virgil
(*Aeneid*, 4, 90 ff)
and depicts
the moment when
Venus gives Aeneas
the weapons forged
by Vulcan, which will
make him victorious
over Turnus.
The subject was
also treated
by Giulio Romano
in the Ducal Palace
in Mantua. Félibien
states that
the painting was
made in 1639
for Jacques Stella.

◆ THE SEVEN
SACRAMENTS: BAPTISM
(1642, Washington,
National Gallery).
The painting is the last
in the series
of the *Seven Sacraments*.
Poussin started
it in Rome, then took
it with him to France
when, at the continued
urging of the king,
he decided in 1640
to return to Paris;
he finished it
in May 1642, and sent
it to Cassiano
in Rome. In the second
series, which
he painted in 1644
for Chantelou,
the figure of Jesus
is shown kneeling
rather than
standing.

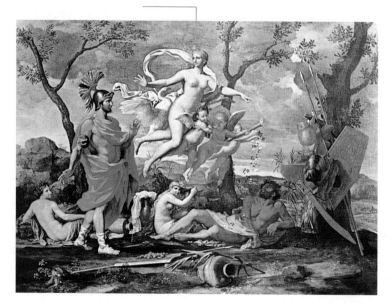

THE LYRICAL EFFUSION OF LANDSCAPE

Poussin's stay in Paris (1641-42), where he held the official post of overseer of the decoration of the Louvre, renewed his contacts with French patrons and the court, and his activity from then on was largely directed to satisfying the requests he received from France, where by this point he was considered the prince of artists.

● As soon as he returned to Rome, Poussin painted for Chantelou the series of *The Seven Sacraments* (a similar series had already been commissioned by his Roman patron

◆ TIME REVEALING TRUTH (1641, Paris, Louvre). The allegorical subject shows Time taking Truth away from Envy and Discord. The particular shape was determined by its destination on the ceiling of the Grand Cabinet of the palace of Cardinal Richelieu, which later became royal property. The circle in the cherub's hand is an attribute of Time, which has neither beginning nor end.

Cassiano dal Pozzo), among the most representative of all the artist's works: a perfect meld of elements of the Renaissance and classical antiquity with the controlled but weighty French morality of Pascal, Racine, Corneille.

● Poussin's approach to an Arcadian sensibility – characterized by a lyrical feeling for nature – was manifested early, because Rome, which already offered excellent examples of landscape in the frescoes decorating Villa Ludovisi, Palazzo Mattei, Palazzo Lancellotti, Villa Rospigliosi, and numerous other patrician residences, was receptive to easel paintings of landscapes as a genre, to hang in private chambers or as *pendants*. First Agostino Tassi (active in Rome between 1610 and 1644) and Filippo Napoletano, and then Claude Lorrain (1600-

82) and Gaspard Dughet (1615-75) emerged as accomplished landscape artists.

● Poussin's later work is characterized by grand sweeping views; after 1650 he placed his compositions in natural settings, influenced also by his brother-in-law Gaspard Dughet. His female figures became increasingly conventional and sculptural, while he seemed to find in nature the fulfillment that human beauty no longer offered him.

● Poussin's moral rigidity hardened along with his

◆ ECSTASY OF ST PAUL (1649-50, Paris, Louvre). Painted for the playwright Paul Scarron, this is one of Poussin's most elaborate religious compositions, reflecting a complex symbolism. The artist had already approached the subject, but in a simpler form, in a painting commissioned by Fréart de Chantelou some time earlier.

style; his palette darkens, the human condition is ever more tragic and painful. By contrast, his landscapes emanate a serene, luminous atmosphere; their luxuriant leaves, springs, and flowers seem to reduce the anguish of human conflict to a mere passing incident. But even his earliest compositions contained, in a certain sense, the future parabola of his landscape painting.

● During the 1660s, nature reigns supreme, and the artist's attention dwells more on its secret aspects, reducing at times the figures to mere presences, as in the *Landscape with Two Nymphs* in Chantilly. Poussin devoted his last years to an extraordinary work: *The Four Seasons*, painted for Richelieu and considered the artist's true cosmic poem.

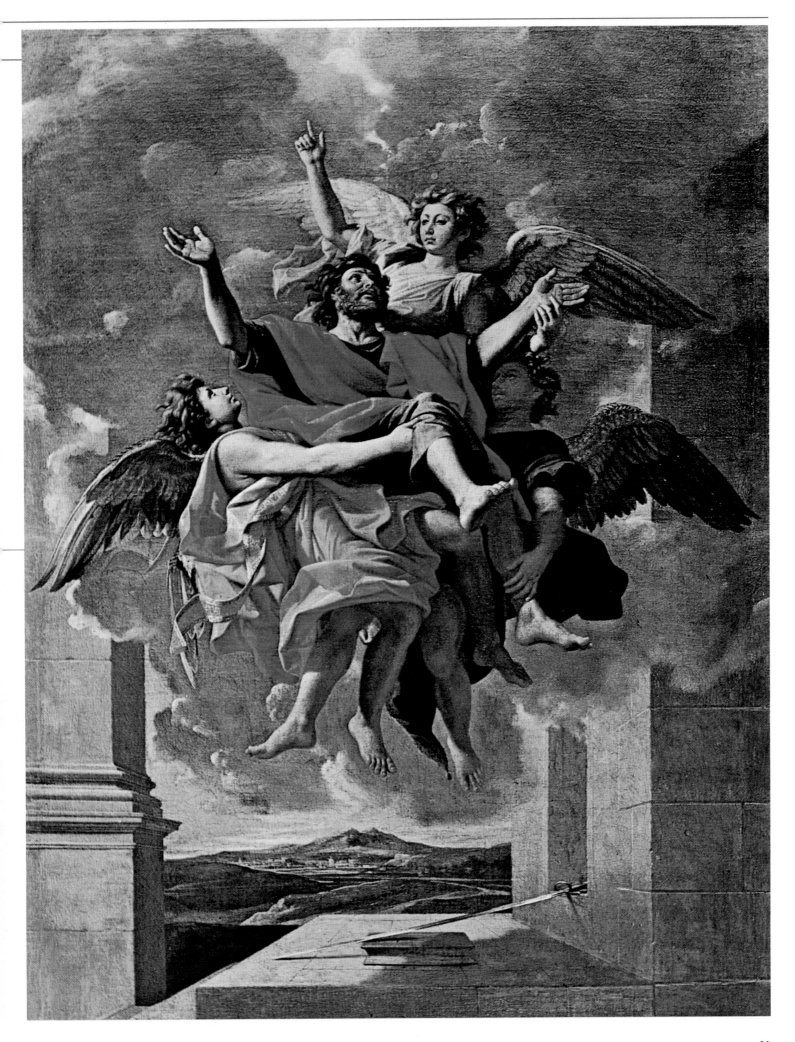

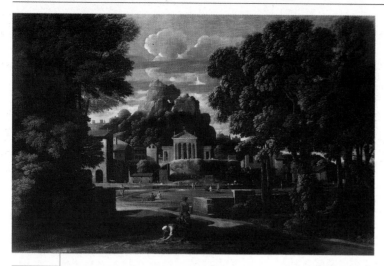

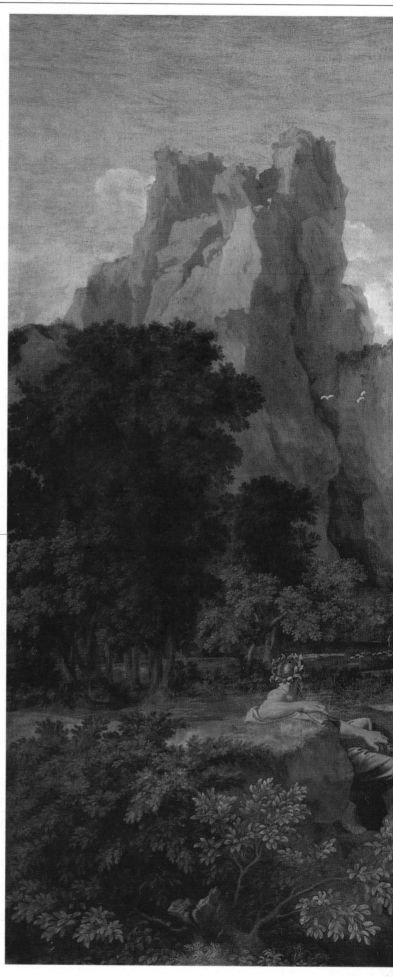

♦ LANDSCAPE WITH THE WIDOW OF PHOCION GATHERING HIS ASHES (1648, Prescott, Earl of Derby). The subject comes from Plutarch's *Lives* and gives Poussin another occasion to reflect on human destiny. When the Macedonian dynasty came to power, Phocion was seen as one to be eliminated; accused of treason, he was forced to drink hemlock.

♦ LANDSCAPE WITH POLYPHEMUS (1649, St Petersburg, Hermitage). According to the myth, the Cyclops Polyphemus, who lived on the slopes of Mt. Aetna, fell in love with the nymph Galatea and tried to woo her away from her young lover Acis, attracting her attention with the sound of a flute.

Poussin chooses the moment when Polyphemus is playing to Galatea, in a luxuriant natural setting on the eastern coast of Sicily, home of the beautiful nymph, who hides behind a rock. Her hair the color of the sea suggests that she is Galatea, the daughter of the sea god Nereus. The story ends with Acis's death.

♦ LANDSCAPE WITH ORPHEUS AND EURYDICE (1649-50, Paris, Louvre). The contrast between individual drama and the serenity of nature is the foundation for a large group of paintings, which includes, among others,

the *Landscape with Polyphemus* and the *Landscape with Orpheus and Eurydice*, and also the *Landscape with Hercules* in Moscow, the *Landscape with Diogenes* in the Louvre, and the *Landscape with a Man Killed by a Snake* in London. The tragic myth

of Orpheus, so in love with his wife Eurydice that he goes to the underworld after her (but when, in his eagerness to look at her, he turns around, and loses her forever), finds its counterpoint in the indifferent beauty of nature.

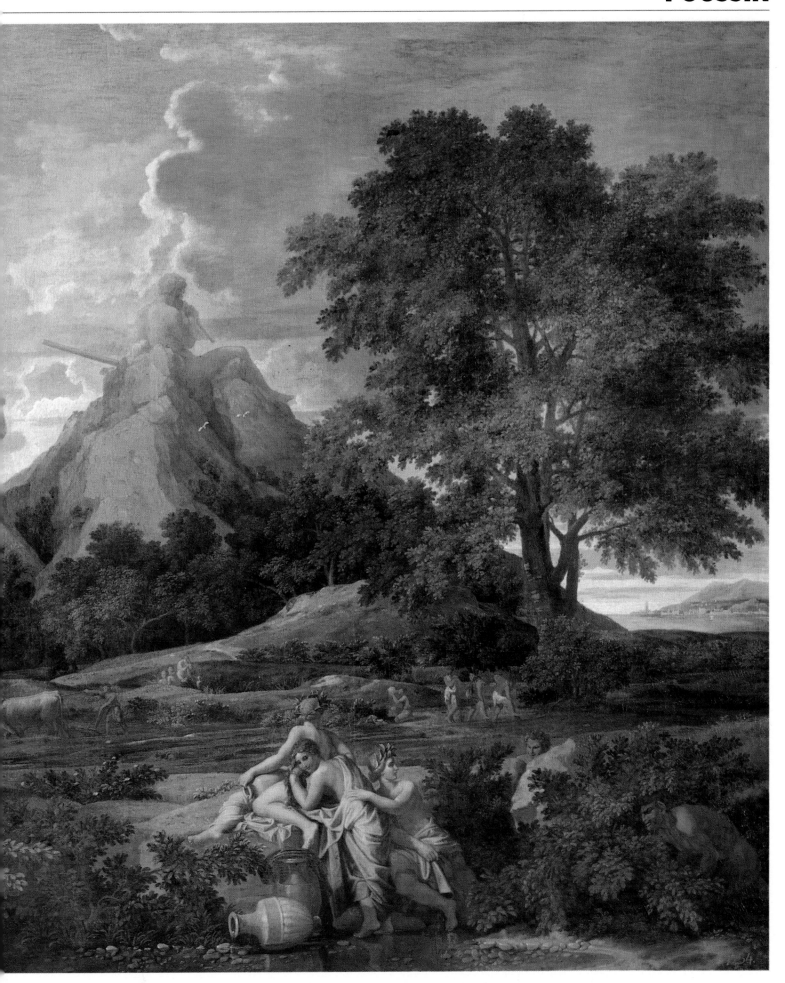

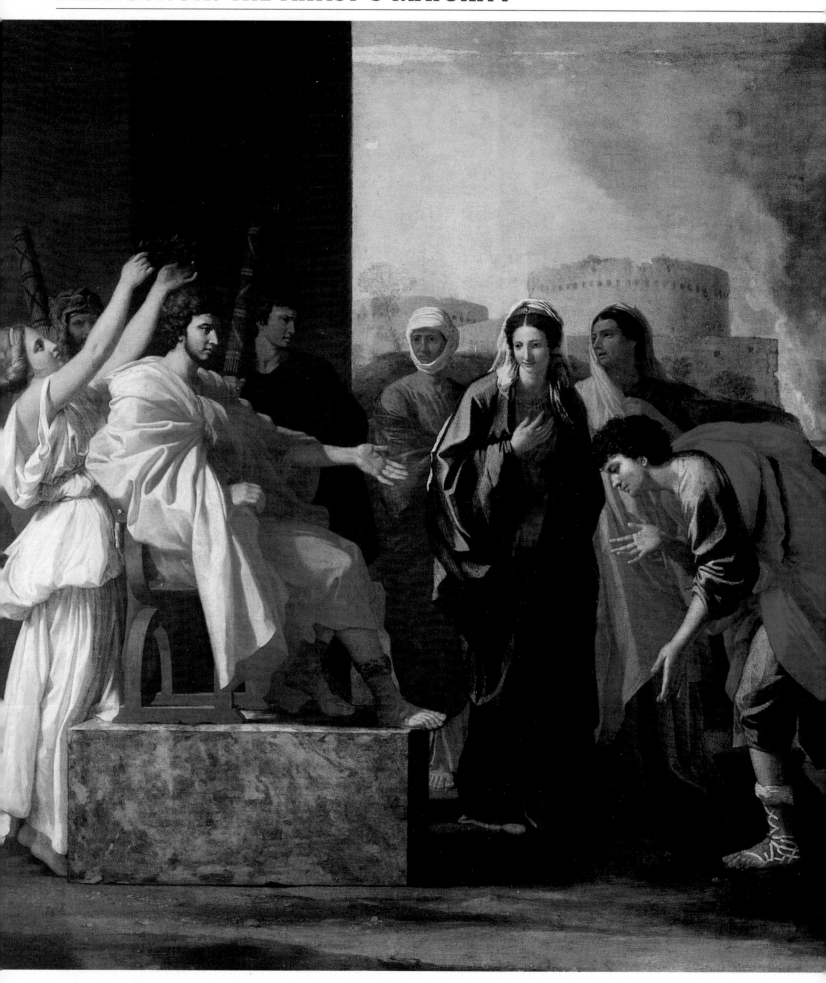

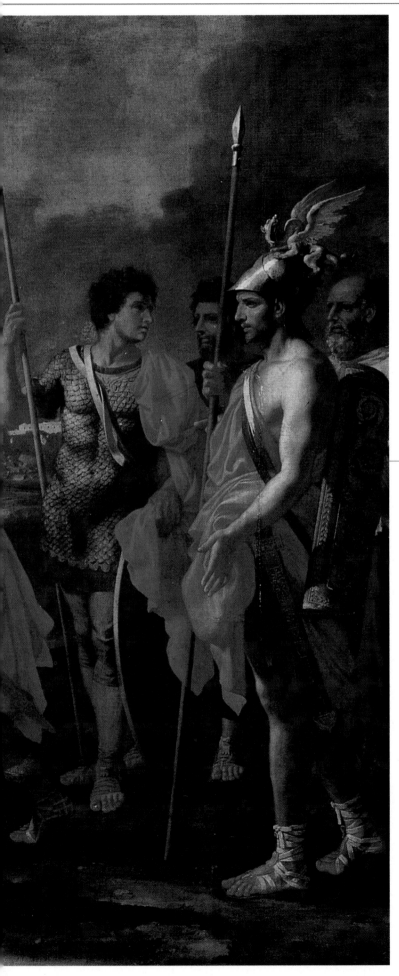

♦ THE CONTINENCE OF SCIPIO

(1640, Moscow, Pushkin Museum). Until a few years ago, it was thought that this painting was made in 1645. Archival research has now revealed that Gian Maria Roscioli, secretary of Urban VIII, bought the canvas from Poussin in 1640. The episode is among the events of the Second Punic War narrated by Livy. Part of the war booty was a beautiful young girl who was assigned to the commander, but as soon as Scipio heard that she was betrothed, he called her future bridegroom and restored her to him.

♦ CHRIST HEALING THE BLIND

(1650, Paris, Louvre). Around 1650 Poussin – as he reveals in his letters – complained of trembling hands, which slowed down his work and gave him a great deal of trouble. Some of his works show a different hand, a sign that in order to keep up with his commitments, he had to leave some things to his students. This painting, for the Lyonais merchant Reynon, is an example. The high quality of Poussin's art is here disappointing, so much so that for some time the work, despite documentation, was thought to be a copy.

♦ ESTHER BEFORE AHASUERUS

(c. 1655, St Petersburg, Hermitage). Painted for the Lyonais merchant Cérisier, the canvas depicts an episode from the Bible's *Book of Esther*. Disobeying the king's orders, the queen goes before the king to plead the Hebrews' cause. Faced with her husband's wrath, her courage fails her and she faints, held up by her handmaidens. The king, surprised and irate, does not wear sumptuous robes, as the Bible says, but a red cloak. The picture differs from the Biblical text also in the number of maids, three instead of two.

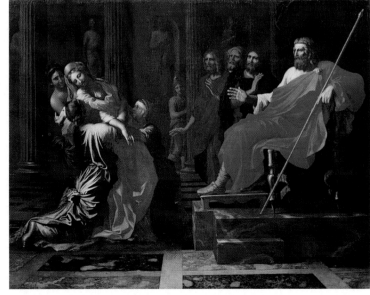

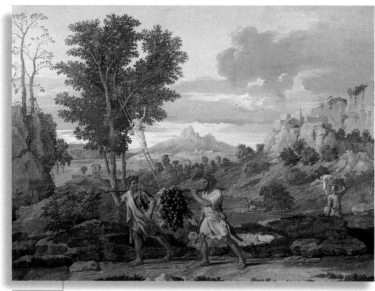

◆ AUTUMN
(1660-64,
Paris, Louvre).
The series, painted
for Richelieu late
in Poussin's life,
can be considered
a sort of spiritual
and artistic testament;
the artist leaves
here the traces
of his course of
meditation and study.
For a true
understanding
of the cycle, it would
be reductive to limit
oneself to theological
interpretations
or iconographical
comparisons:
Autumn is a tribute
to the abundance
of nature; it is
the fruitful
Promised Land.

◆ WINTER
(1660-64, Paris,
Louvre).
Winter, man's last
season, is depicted
by Poussin as
full of shadows,
as inescapable
as the Flood.
But the protagonist
of the painting is not
death, but hope.
The presence of
a snake slithering
into the shadows
testifies to the eternal
fertility of the earth
and its capacity for
regeneration, while
awareness of man's
smallness and his
inability to save
himself by his
own strength are
alleviated by the hope
placed in the ark.

◆ SUMMER
(1660-64, Paris,
Louvre).
The season
is evoked by the Bible
story of Ruth and Boaz,
a story of faithfulness
and perseverance,
rewarded in the
end by the gift
of fertility, just as
the harvest is
the farmer's
compensation for
his hard, unending
labor. A field of grain
spreads before our
eyes and leads the gaze
to the mountains in
the background,
with the laborers busy
reaping and threshing,
while in the foremost
plane Ruth kneels
in front of
the elderly Boaz.

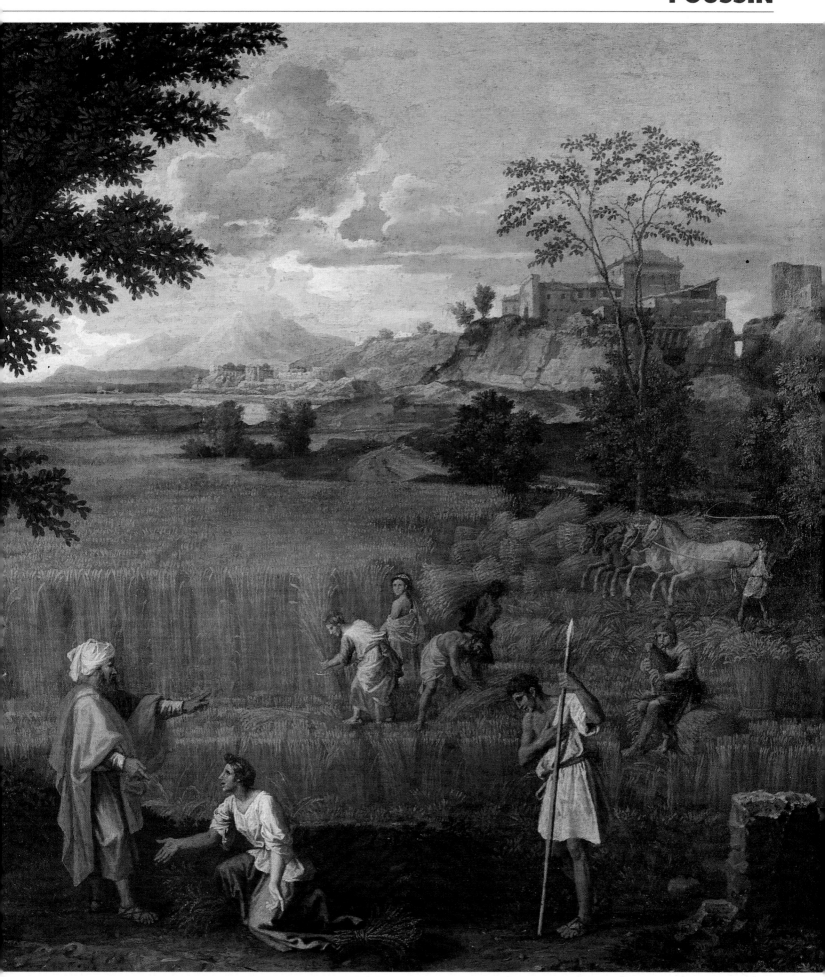

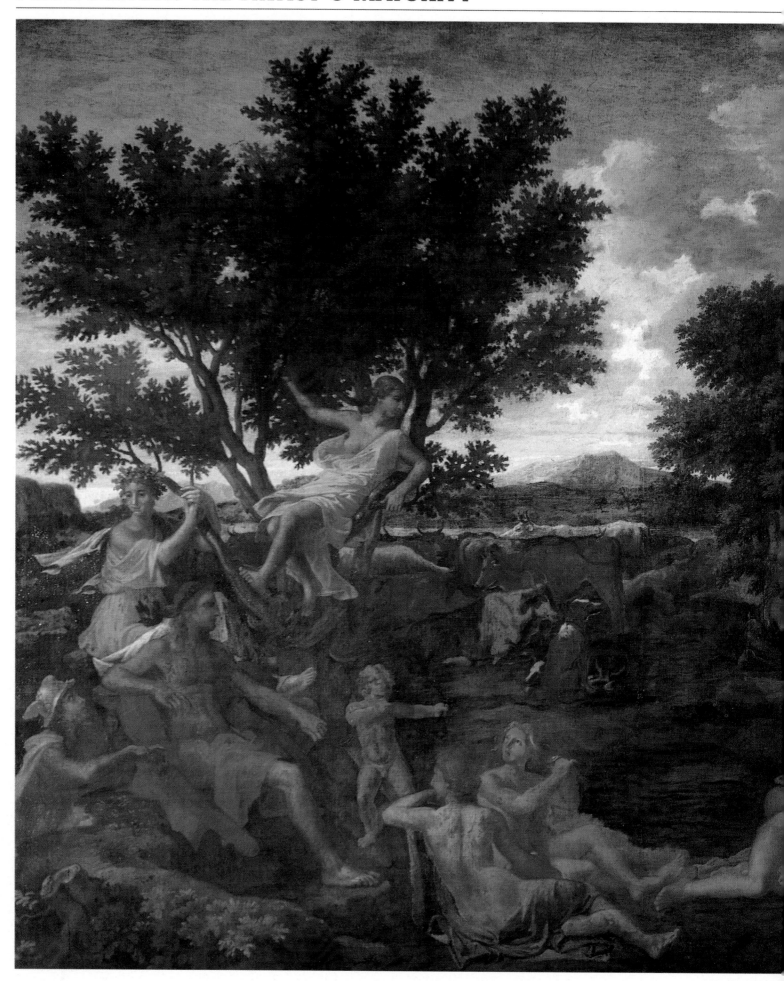

◆ **APOLLO AND DAPHNE**
(1664, Paris,
Louvre).
This unfinished
work seems to
have been given
by Poussin on his
deathbed to Camillo
Massimi; in 1869
it was purchased
by Napoleon
for the Louvre.
Some of the figures
remained in
a sketchy state,
but the overall
composition strikes
and moves
the viewer
because of the tone
Poussin adopts
to lead us into
Apollo's mind,
revealing to us his
perfect proportions,
moral order,
his unhappy love,
his power to inspire
in music and poetry.

◆ **SPRING**
(1660-64, Paris,
Louvre).
"His last great poem
is *The Four Seasons*
in the Louvre,"
wrote Jacques
Thuillier. *Spring*
is interpreted
by Poussin as
the happy
childhood
of mankind:
the Earthly Paradise
of the first parents,
the innocence
of an age when
men lived happy
and fulfilled.
The representation
of Spring includes
also that of
a fertile, luxuriant
nature, the generous
giver of water,
fruit, life, capable
of infinitely
regenerating
herself.

◆ **REBECCA AT THE WELL**
(1648, Paris, Louvre).
Painted for Pointel,
then passing into
the hands of Richelieu
and from him to King
Louis XIV, the canvas is
considered one
of the most important
creations of the artist's
maturity. The Bible
story (*Genesis*
24:15-20) narrates
the encounter between
Eliezer, the elderly
servant entrusted by
Abraham with finding
a wife for Isaac among
his own people, and
Rebecca at the well,
where the girl had
gone with other women
from the city of
Aramnaharaim to draw
water toward evening.
Once again the painter
offers an occasion
to meditate
on human destiny.

CLASSICISM AND BAROQUE

At the beginning of the seventeenth century, Rome was the point of convergence for artists from all over Europe, and among the Dutch artists Van Laer (called Bamboccio), Honthorst, and Ter Brugghen, the French Valentin and Lorrain, the Fleming Rubens, and the Spaniard Velázquez, the dominant and most charismatic figure was without doubt Poussin.

● Unsuited by character and distant from the turbulence of Baroque culture, with a closer affinity for the measured, rational French taste, cultivated and reserved, Poussin was the most intellectual painter of his time. Attracted by the lessons of the Carracci family, the ideal of moderation of Guido Reni, the balance of Domenichino, he gave new vigor to Classicism in painting just as Algardi (1595-1654) did in sculpture. The two artists shared a tendency to ponder which led them to a profound interpretation of their respective themes, in a conception of the classical that was both aesthetic and moral.

● The artistic panorama of that period of-

◆ **GASPARD DUGHET**
View of the Roman Countryside
(1644-45, Lille, Musée des Beaux-Arts). Dughet, known in the 17th century for his landscapes, painted many views of the Roman countryside with ruins.

◆ **ANNIBALE CARRACCI**
The Flight into Egypt
(c. 1605, Rome, Galleria Doria Pamphilij). The historical-religious event is melded with the landscape in a global imaginary vision in which history (the past) and nature (present) become myth.

fered a great variety of languages. Guercino's arrival in Rome and his allegories of *Day* and *Night* in the Casino Ludovisi opened a new window onto the Venetian sense of color and light, which would reach new heights in the development of the Baroque *gran gout*. At the same time, the renewal of Annibale Carracci's concepts of ornamentation found in the genius of Giovanni Lanfranco, from Parma, the beginning of grand Baroque ornamentation. Even Pietro da Cortona abandoned his earlier mythological stories to construct grandiose, spectacular compositions, like the remarkable ceiling of the Salone Barberini, where the *Triumph of Divine Providence* (1633-39) seems to demonstrate that content is only a pretext for an art viewed as the technique of the visible and the ostentatious.

● The new Baroque current was only apparently opposed to Classicism; in reality the classical ideal of the followers of Carracci, Domenichino, and Poussin was interwoven with the showier manner and themes of the Baroque in a process of mutual exchange and merging.

◆ **GUIDO RENI**
Deianira Abducted by the Centaur Nessus
(1621, Paris, Louvre). With Reni, reflection on Renaissance painting is enriched by the contribution of an artist who had studied Roman sculpture deeply. His classicism is seen in the rhythm and cadence of a human but unattainable beatuy. This painting is part of a series of four *Labors of Hercules*.

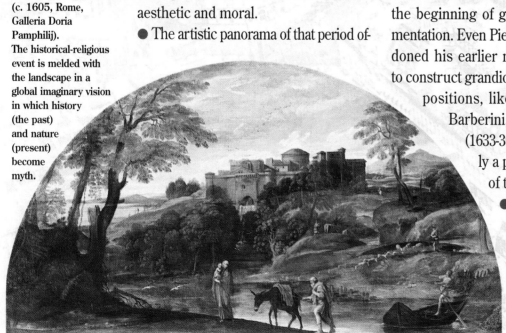

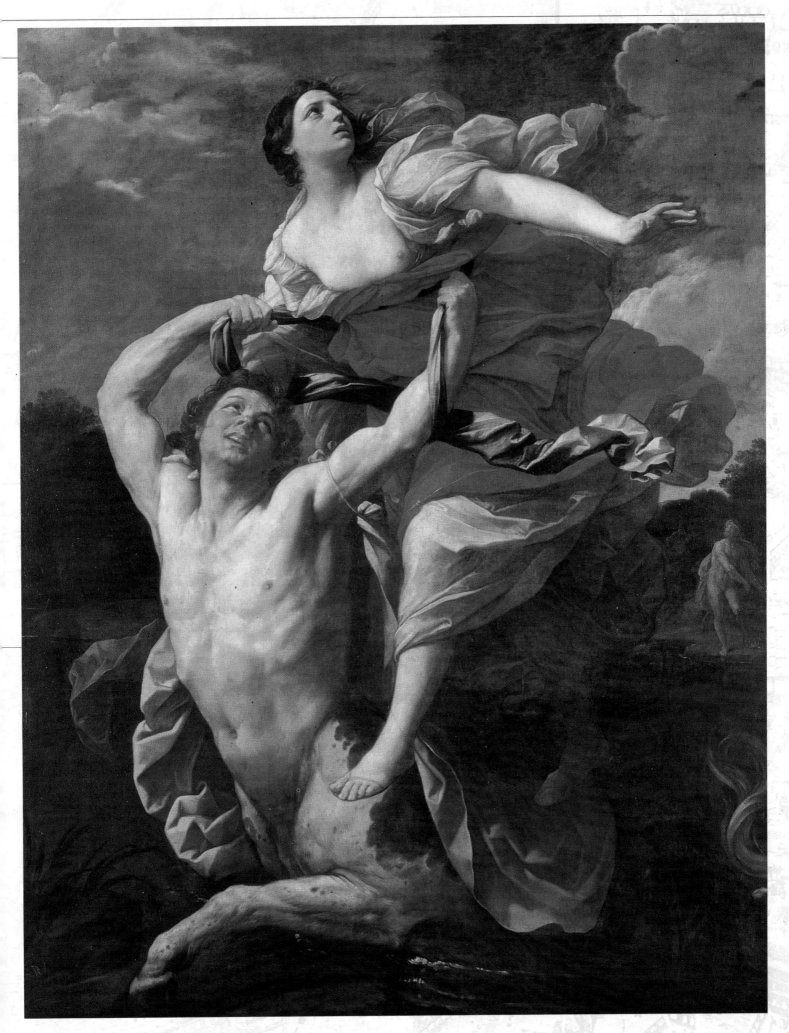

THE CLASSICAL IDEAL: A FILTER BETWEEN EXTREMES

The uniqueness of the greats is unrepeatable, and this is true of the originality of Poussin's development in forty years of intense activity. His spiritual journey is contained in the artistic production he left behind, the fruit of a profound meditation and constant self-interrogation on the essence of man and human destiny.

● The artist's personal torment took its toll on his health; the bitterness and anguish of existence produced in him a hardness of character that melted only in his last works, which reveal a newfound serenity. The spiritual dialogue set up between Poussin and his art, given these premises, could not constitute an easy model for those who, admiring its results, wanted to follow its presuppositions.

● Andrea Sacchi (1599-1661) is the artist who came closest to Poussin's classical ideal, but Pietro Testa (1611-50), called Lucchesino, and Pier Francesco Mola (1612-66) were closest to his artistic world. Carlo Maratta (1625-1713) popularized, through a dignified but essentially superficial interpretation, Poussin's classical ideal, without however grasping its profound sense and melancholy evocation of a lost harmony between mankind and nature.

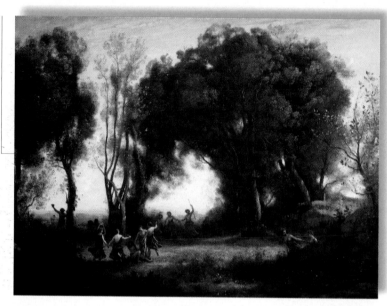

♦ **CAMILLE COROT**
A Morning, Dance of the Nymphs **(1850-51, Paris, Musée d'Orsay). Poussin's conception of nature bridges the centuries and reappears, as inspiration, even in the free, impetuous manner of Corot and the Romantic movement. Like Poussin, Corot stayed at length in Italy, attracted by the colors of the Mediterranean.**

● Landscape is quite a different matter. Already with Annibale Carracci the landscape had become a significant element of the story, on the same level as the figures. After Poussin, Claude Lorrain dealt not with the harmonious integration of the landscape with a noble, heroic subject, but with a comparison of man's heroism and the grandeur of nature, especially in paintings inspired by Virgil's *Aeneid*. Through Lorrain, Poussin's message, especially that conveyed by the *Four Seasons*, reached all the way to the nineteenth century, to Camille Corot (1796-1875), whose painting expressed the natural serenity of the dawn.

● But Poussin's classical ideal would later be the object of careful analysis and reflection by artists who would give life to a new season of neo-Classical art, like Jacques-Louis David, or would rework it in the pre-Romantic elaboration of *Sturm und Drang*, like Johann Heinrich Fuseli.

♦ **JACQUES-LOUIS DAVID**
The Loves of Paris and Helen **(1789, Paris, Louvre). The reference to the grand painting of Poussin is evident, even if given in a neoclassical sense, with an attention to philological accuracy in the meticulous reconstruction of the details.**

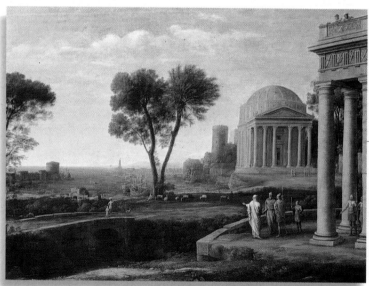

♦ **CLAUDE LORRAIN**
View of Delos with Aeneas **(1672, London, National Gallery). The painter was part of the group of young foreign artists (Poussin, Lemaire, Van Swanevelt), who lived in Rome between Via Margutta and Via del Babuino and, as Joachim von Sandrart (1606-1688) tells us, would leave early in the morning to paint the Roman countryside from life.**

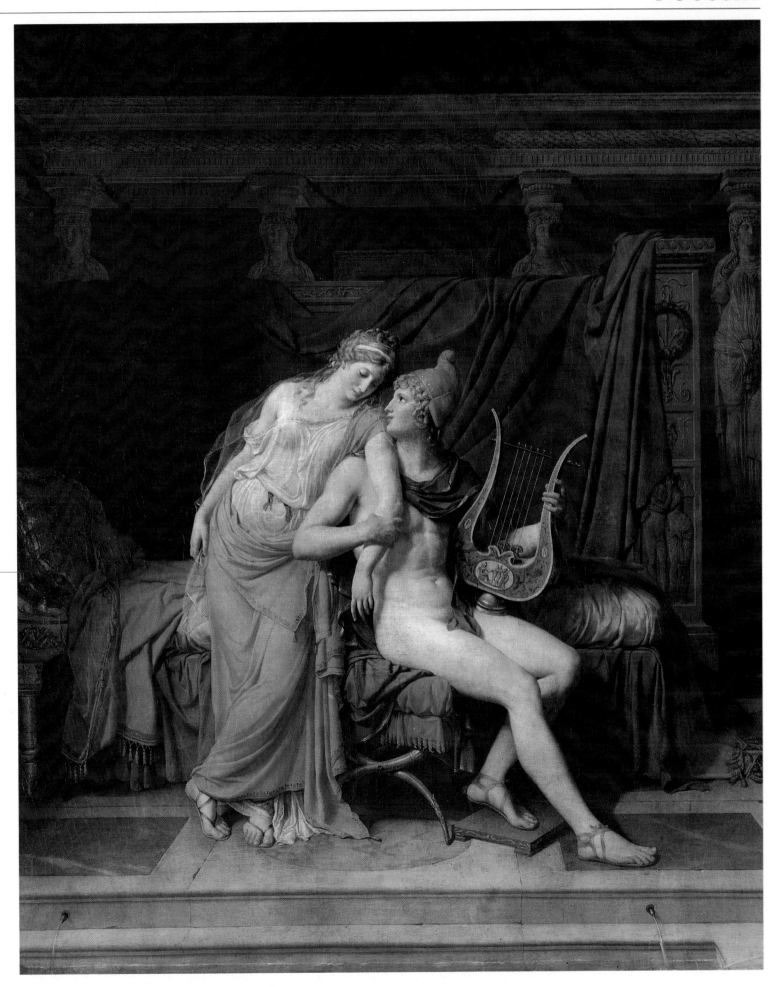

THE ARTISTIC JOURNEY

For an overall view of Poussin's production,
we provide a chronological catalogue of his major works

◆ JOSHUA FIGHTING THE AMORITES (1624-25)

The battle was painted in a moment of particular indigence for the artist, who had just arrived in Rome and did not yet have the support of his protector and patron Cassiano dal Pozzo. The canvas, together with another one on a similar Biblical subject, was sold for very little money. It recalls the dynamic narrative model of Lanfranco and replicates some figures from Polidoro da Caravaggio.

◆ VENUS AND ADONIS (1624-25)

Adonis (1623) by Giambattista Marino, Poussin's friend, and the *Metamorphoses* (X, 529 ff.) are the literary sources inspiring the painter here to narrate a happy moment in the love story between the handsome young Adonis and the goddess. The joyous atmosphere is reinforced by the serene expression of the cherubs, frequently present in Poussin's works, complementing the meaning of the subject depicted.

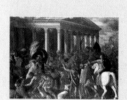

◆ THE SACK OF THE TEMPLE OF JERUSALEM BY TITUS'S TROOPS (1625-26)

The canvas was restored to Poussin's catalogue in 1995 by Denis Mahon. The whereabouts had been lost of this valuable witness to Poussin's first Roman period, as over the centuries the work had passed through many hands, starting with Cardinal Barberini, who gave it to Richelieu as a gift.

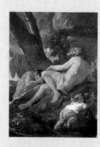

◆ MIDAS AT THE SOURCE OF THE RIVER PACTOLUS (c. 1626)

This is a rather unusual subject and might have fascinated Poussin for its ethical implications. A meditation on human destiny is interwoven here with a reflection on the granting of wishes. The silent presence of the river god functions as a topographical indication, but the god also takes on the role of spectator and witness to the story.

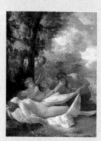

◆ SLEEPING NYMPH WITH SATYRS (1626-27)

Presented as an original work by Denis Mahon in 1999, in the exhibition devoted to Poussin's first Roman period, the canvas presents a subject the artist treated many times in easel paintings, which were easily sold. The production of paintings for sale, while on one hand frees the artist to choose his subject, on the other forces him to paint the genre most popular with the public.

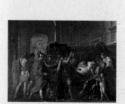

◆ THE DEATH OF GERMANICUS (1626-28)

The episode is taken from the *Annals* by Tacitus. At their commander's deathbed, next to the grieving Agrippina, his officers swear to avenge him. The epic tone is combined with the ethical theme, in an attempt to express the affections. The vertical rhythm of the space occupied by the figures recalls Roman bas-reliefs, with an arrangement parallel to the picture plane.

◆ THE TRIUMPH OF FLORA (c. 1627)

The theme of time and the seasons is underlined by the presence of Venus-Spring. The lyrical beauty of the composition evokes an ideal world where all is grace and light, but even for the figures inhabiting it, love and beauty are founded on the suffering and torment which they themselves produce with their desires and unhappy loves.

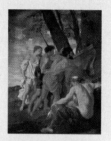

◆ THE ARCADIAN SHEPHERDS (ET IN ARCADIA EGO) (1628-29)

The figure in the foreground is a river god; this is the first time that Poussin treats the nude in such detail. A group of solidly constructed figures reads the inscription, "Et in Arcadia Ego" on the sarcophagus, a melancholy reminder of the fleeting nature of happiness. It is evident that the artist is beginning to pay greater attention to anatomy.

◆ THE MARTYRDOM OF ST ERASMUS (1628-29)

The artist was at the top of the Roman cultural scene, and the public destination of the painting confirms this. The martyrdom is seen as a cruel, sadistic murder which takes place, by contrast, in a dazzling light. The winch on which the saint's intestines are being wound is a detail of raw naturalism, balanced by the serene classicism of a statue of Hercules presiding over the martyrdom.

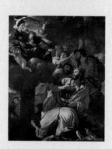

◆ THE VIRGIN APPEARING TO ST JAMES (1628-30)

The altarpiece, commissioned by a Spanish patron for a church in Valenciennes, was later purchased by the Duke of Richelieu. It documents the artist's effort, enacted with great energy, to measure himself against Baroque painting: this could have been a turning point in Poussin's style, but instead remained an isolated instance.

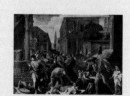

◆ THE PLAGUE OF AZOTH (1630-31)

The plague which struck Milan and a large part of northern Italy in 1630 may have suggested to Poussin that this Bible story would have been a topical one and thus easily sold. In fact, it was immediately bought by the Sicilian aristocrat Fabrizio Valguarnera who also ordered a copy of it from the painter Angelo Caroselli.

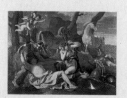

◆ TANCREDI AND ERMINIA (1630-31)

Poussin was the first to paint this episode from Tasso's *Gerusalemme Liberata*. The composition is based on diagonals which emphasize the tension of the figures, conveying a strong emotional charge. The kneeling figure of Vafrino forms a compact group with Tancredi, while the diagonal created by Erminia's body intersects with that of the two men and culminates in the sword.

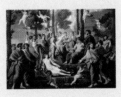

♦ PARNASSUS (1631-35)

Apollo and the nine Muses gather around the Castalian spring, whose water transmits to those who drink it the passion for and gift of poetry. On either side of the central group are the greatest poets of antiquity, identifiable by their laurel wreaths. The theme, already magnificently illustrated by Raphael in the Stanza della Segnatura in the Vatican, was a particular favorite of Classicist painters.

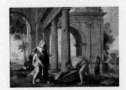

♦ THESEUS FINDING HIS FATHER'S SWORD (1633-34)

Aegeus, Theseus's father, after coupling with Aethra, hid his sword and sandals under a rock and told her that, if a son should be born of their union, she should send him to Athens as soon as he was able to lift the heavy stone. This was done, and after many adventures the young man reached Athens, where he was recognized by his father and named heir to his throne.

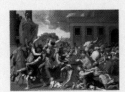

♦ THE RAPE OF THE SABINES (c. 1634)

A meditation on fate and the instruments it uses to fulfill human destiny underlies this extraordinary work, inspired by one of the most famous episodes of early Roman history, narrated by Livy in his *Historiae*. Another version of *The Rape of the Sabines*, now in the Louvre and a large canvas like this one, was painted a few years later (1637-38).

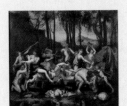

♦ THE TRIUMPH OF PAN (1634-37)

The painting belongs to the series of four canvases called the *Bacchanals*, commissioned by Cardinal Richelieu to decorate a room in his chateau at Poitou. All the sources agree that there were three "ground" *Bacchanals* and a "sea" one. There is an identical version of this painting in the National Gallery in London.

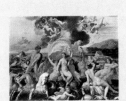

♦ THE TRIUMPH OF NEPTUNE (1634-37)

The painting is part of Richelieu's series of *Bacchanals*. Neptune rides the crest of the waves with his team of horses, with Venus close behind in her shell-shaped chariot, accompanied by Nereids and Tritons. The decision to include a marine triumph along with the three terrestrial ones is probably a reference to the role attributed to Richelieu of restorer of the French navy.

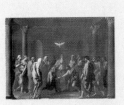

♦ THE SEVEN SACRAMENTS: MARRIAGE (1636-40)

Poussin responded to the vast decorative series of Pietro da Cortona, besides the *Bacchanals*, with a series of paintings centering on the institution of the sacraments, commissioned by Cassiano dal Pozzo. The first canvas to be painted was *Extreme Unction*; *Confession* was destroyed in a fire. The last was *Baptism*, which Poussin took with him to France and completed in 1642.

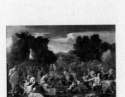

♦ THE FALL OF MANNA (1637-38)

The painting was made for Fréart de Chantelou. The Bible story is one of the stories of Moses, from which Poussin often drew inspiration for the high moral content of their teachings. The subject was painted in that same period also by Rubens and by Giovan Francesco Romanelli, a painter in the circle of Pietro da Cortona, an indication of the public's appreciation of meditations on the insatiable nature of human passions and desires.

♦ MOSES IN THE BULRUSHES (1638)

The destiny of the great leader of Israel is contained in his salvation from the waters of the Nile: Pharaoh's daughter takes compassion on him and adopts him, calling him Moses, "drawn from the water." This is the best-known version of the theme, which Poussin painted several times. The cadence of the figures is even more harmonious here than in the version painted in 1647 for Pointel, also in the Louvre.

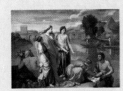

♦ THE CONTINENCE OF SCIPIO (1640)

Archival research has revealed that Gian Maria Roscioli, secretary of Urban VIII, bought the canvas (earlier thought to be of 1645) from Poussin in 1640. The episode inspiring the painting is among the events of the Second Punic War narrated by Livy. Part of the war booty was a beautiful young girl, assigned to Scipio, but as soon as he heard that she was betrothed, he called her future bridegroom and returned her to him.

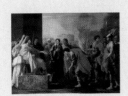

♦ THE SEVEN SACRAMENTS: BAPTISM (1644-48)

The second series of this subject was requested from Poussin by Fréart de Chantelou, as documented by frequent correspondence. Chantelou would have been happy with a simple replica of the first version, but neither Richelieu nor Poussin were willing. The artist conceived a new series that was much more profound and graver in tone than the first. Chantelou hung the pictures so that all could admire them

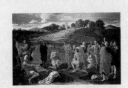

♦ LANDSCAPE WITH THE WIDOW OF PHOCION GATHERING HIS ASHES (1648)

The subject comes from Plutarch's *Lives* and gives Poussin another occasion to reflect on human destiny. When the Macedonian dynasty came to power, Phocion was seen as one to be eliminated; accused of treason, he was forced to drink hemlock. Poussin begins to devote very close attention to nature.

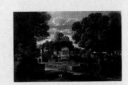

♦ LANDSCAPE WITH POLYPHEMUS (1649)

Polyphemus, who lived on the slopes of Mt. Aetna, fell in love with the nymph Galatea and tried to woo her away from her young lover Acis, attracting her attention with the sound of a flute. Poussin chooses the moment when Polyphemus is playing to Galatea, in a luxuriant natural setting. The story ends tragically with the death of Acis.

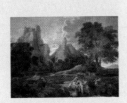

♦ ESTHER BEFORE AHASUERUS (c. 1655)

The canvas depicts an episode from the Bible's *Book of Esther*. The queen, at her own initiative, goes before the king to plead the Hebrews' cause. Faced with her husband's wrath, her courage fails her and she faints, held up by her handmaidens. Poussin deviates from the biblical text in two details: there are three handmaidens instead of two, and Ahasuerus wears a red cloak instead of royal robes.

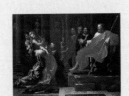

♦ THE FOUR SEASONS: SUMMER (1660-64)

The series, painted for Richelieu toward the end of Poussin's life, can be considered a sort of spiritual and artistic testament. He leaves in these canvases the traces of his course of meditation, study, and suffering. The season is evoked by the Bible story of Ruth and Boaz, a story of faithfulness and perseverance which is rewarded in the end by the gift of fertility.

TO KNOW MORE

The following pages contain: some documents useful for understanding different aspects of Poussin's life and work; the fundamental stages in the life of the artist; technical data and the location of the principal works found in this volume; an essential bibliography

DOCUMENTS AND TESTIMONIES

Following are excerpts from Poussin's correspondence, Lettres et propos sur l'art, *which reveal how both the serious, thoughtful demeanor that we see in his self-portrait in the Louvre and the quiet, melancholy face in the other self-portrait, shown on this page, are different sides of the same man.*

A many-sided personality

"Would to God that I did not have such serious excuses to offer you. Very soon after resolving to finish your picture [*The Fall of Manna*] and after having even done some of the figures, a bladder problem, from which I have suffered for four years now, has troubled me so much that since then I have been in the hands of surgeons, tormented like a damned man; but thanks be to God I am better, and I hope that my health will return as before. I must say that melancholy has overcome me for not having been able to finish your painting, which has made me feel worse than anything else; and thinking always about the promise I made you, being held back has made me desperate. Now I feel a greater desire than ever to serve you. [...]"

[N. Poussin, Letter to Chantelou, Rome, 15 January 1639]

"Things which reveal a certain amount of perfection cannot be viewed hurriedly, but with time, discernment, and intelligence. The same methods must be used for judging them properly and for making them properly. [...] It comes to me as a great relief when, in the midst of our work, there is some interval which lightens the burden. I have never been so desirous of facing the labor of work as when I have seen some beautiful object. But, woe is me! Here we are too far away from the sun to be able to see anything truly pleasing to the eye. [...]"

[N. Poussin, Letter to Chantelou, Rome, 20 March 1642]

"Lately I have had the honor of receiving a letter from Monsignore dated 23 March, which begins with these words: 'Poussin's genius wants such freedom of movement that I wish only to indicate to him what the King's genius desires from his.' Sir, I have never known what the king wanted from me, who am his very humble servant, and I do not believe that he has ever been told what my qualities are. [...] Nonetheless, I cannot understand well what Monsignore desires from me without a great deal of confusion, since it is impossible for me to

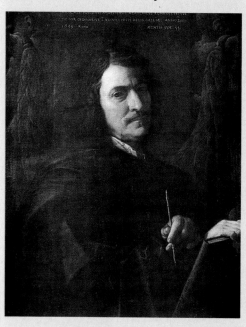

Self-portrait, **1649, Berlin, Bodemuseum**

do at the same time frontispieces for books, a picture of the Virgin, the painting for the congregation of Saint Louis, all the drawings in the gallery, and the designs for the royal tapestries. I only have one hand and one weak head, and I can have no help or relief from anyone. He says that I could distract myself with beautiful inventions in doing the above mentioned Virgin and the Purification of Our Lord; it is the same thing as when someone says: you can do that drawing in your spare time. [...] You will excuse me, Sir, if I speak so freely. My nature makes me seek and love well-ordered things, fleeing from confusion which is as much my enemy as the light is the enemy of darkness."

[N. Poussin, Letter to Chantelou, Paris, 7 April 1642]

Bernini's opinion

The artist's reaction to some of Poussin's works, when he visited Chantelou in 1665, is described by Fréart de Chantelou himself in this passage.

"He went to the Salon where *The Seven Sacraments* were hanging, of which the only painting that was uncovered was *Confirmation*. He observed it very devotedly, exclaiming: 'He has imitated the color of Raphael in this painting; it is a beautiful narrative. What devotion! What silence! How beautiful is that young maid!'. [...] Then he had *Marriage* unveiled, and examined it as he had done the first without saying a word, moving back the curtain which covered part of a figure behind a column. [...]
In the meantime I had *Extreme Unction* brought down and put it near the light, so that the Cavalier could see it better. He looked at it, standing up, for a long time, then knelt down to see it better, changing his glasses every so often, manifesting all his wonder without speaking. Finally he got up and said that the painting produced the same sensation as a sermon that one follows very attentively, and that one comes away from without saying anything, but whose effect one feels inside. [...]
He asked if I owned all seven. I told him yes. He did not tire of looking at them for a whole hour. Then, getting up, he said: 'You have given me a great displeasure today, showing me the virtue of a man who makes me know that I do not know anything,'. [...] After this, he saw the remaining sacraments and observed them as closely as he had the others. He then saw [in Cérisier's collection] the large landscape of *The Death of Phocion*, and found it beautiful; about the other one, where his ashes are gathered, he said after observing it for a long time: 'Monsieur Poussin is a painter who works from here,' pointing to his forehead. I told him that his works were the fruit of his mind, as he had always had clumsy hands. [...]"

[Fréart de Chantelou, *Journal de voyage du Cavalier Bernini,* 1665]

1594. Nicolas Poussin was born in Les Andelys in Normandy, the son of a nobleman, Jean Poussin, and Marie Delaisement, daughter of a judge.

1612-14. Worked in the studio of a painter in Rouen; in Paris studied with the painters Elle le Vieux and Lallemand.

1614-16. Economic difficulties forced his return to the family. Back in Paris later, he studied at Fontainebleau.

1616-19. The mirage of Rome led him to set out on a trip that was cut short in Tuscany. Back in France, he tried again in 1619; this trip was interrupted in Lyon.

1622-23. Met Giambattista Marino; made drawings for his *Adonis*, inspired also by the *Metamorphoses*. The poet invited him to Rome.

1624. Finally in Rome, he was introduced to the powerful cardinals Sacchetti and Barberini; the latter presented him to Cassiano dal Pozzo.

1625. A year of financial difficulties; Marino died, and Poussin's patron Cassiano was in Paris.

1626. Lived on via Paolina (now called del Babuino) with François Duquesnoy. Cardinal Barberini commissioned *The Death of Germanicus*.

1628-29. Received the important commission for *The Martyrdom of St Erasmus*.

1630-31. Married Anne Marie Dughet. Painted for Fabrizio Valguernera *The Plague of Azoth* and *The Kingdom of Flora* now in Dresden.

1636-40. Worked on the *Bacchanals* for Richelieu and *The Seven Sacraments* for Cassiano dal Pozzo.

1640-42. Yielding to the king's insistent pressure, he returned to France.

1642. On the pretext of going to get his wife, he left for Rome and did not go back to France.

1643. Continued working on French commissions and for King Louis XIII.

1644. Began working for Chantelou on the second series of *The Seven Sacraments*.

1645-48. Worked unstintingly and began the series of large historical-philosophical landscapes.

1649. Painted his first self-portrait for his friend Pointel and began another for Chantelou.

1650-56. Painted one after the other the most famous works of his mature period.

1657. His patron Cassiano dal Pozzo died.

1658-63. Poussin suffered from illness, yet still managed to paint some of his best works.

1664. Lost his wife and gave his last, unfinished work to Camillo Massimi.

1665. Laid down his brush for the last time, and died toward the end of the year, on November 19.

The following is a catalogue of the principal works by Poussin conserved in public collections. The list of works follows the alphabetical order of the cities in which they are found. The data contain the following elements: title, dating, technique and support, size in centimeters, location.

BELVOIR CASTLE (GREAT BRITAIN)
The Seven Sacraments: Marriage, 1636-40; oil on canvas, 95.5x121; Rutland collection.

The Seven Sacraments: Extreme Unction, 1636-40; oil on canvas, 95.5x121; Rutland collection.

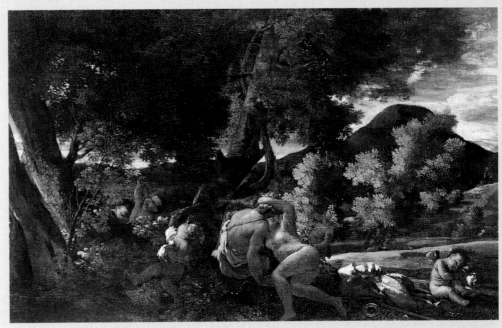

Landscape known as Grottaferrata, 1626, Montpellier, Musée Fabre

The Seven Sacraments: Confirmation, 1636-40; oil on canvas, 95.5x121; Rutland collection.

The Seven Sacraments: Ordination, 1636-40; oil on canvas, 95.5x121; Rutland collection.

The Seven Sacraments: The Eucharist, 1636-40; oil on canvas, 95.5x121; Rutland collection.

BERLIN (GERMANY)
Apollo Granting Phaethon his Chariot, 1633-38; oil on canvas, 122x153; Staatliche Museen.

Self-Portrait, 1649; oil on canvas, 78x85; Bodemuseum.

CHANTILLY (FRANCE)
Theseus Finding his Father's Sword, 1633-34; oil on canvas, 98x134; Musée Condé.

Landscape with Two Nymphs, 1659; oil on canvas, 118x179; Musée Condé.

CHATSWORTH (GREAT BRITAIN)
The Arcadian Shepherds (Et in Arcadia Ego), 1628-29; oil on panel, 101x82; Duke of Devonshire collection.

DRESDEN (GERMANY)
The Kingdom of Flora, 1631; oil on panel, 131x181; Staatliche Kunstsammlungen.

Pan and Syrinx, c. 1637; oil on panel, 106.5x82; Staatliche Kunstsammlungen.

DUBLIN (IRELAND)
Acis and Galatea, 1628-29; oil on panel, 97x135; National Gallery of Ireland.

EDINBUGH (GREAT BRITAIN)
The Seven Sacraments: second series, 1644-48; oil on canvas, 117x178; National Gallery of Scotland.

FRANKFURT (GERMANY)
Landscape with Pyramus and Thisbe, 1651; oil on canvas, 192.5x273.5; Städelsches Kunstinstitut.

HANNOVER (GERMANY)
The Poet's Inspiration, c. 1627; oil on panel, 94x69.5; Niedersächsische Landesgalerie.

LONDON (GREAT BRITAIN)
Sleeping Nymph with Satyrs, 1626-27; oil on canvas, 66x50.5; National Gallery.

Cephalus and Aurora, 1631-33; oil on canvas, 96.5x130.5; National Gallery.

Bacchus Fed by Nymphs, 1630; oil on canvas, 75x97; National Gallery.

MADRID (SPAIN)
Parnassus, 1631-35; oil on canvas, 145x197; Prado.

MINNEAPOLIS (UNITED STATES)
The Death of Germanicus, 1626-28; oil on canvas, 148x196; Institute of Arts.

MOSCOW (RUSSIA)
Joshua Fighting the Amorites, 1624-25; oil on canvas, 97.5x134; Pushkin Museum.

The Continence of Scipio, 1640; oil on canvas, 116x150; Pushkin Museum.

MUNICH (GERMANY)
Apollo and Daphne, 1626-27; oil on canvas, 97x131; Alte Pinakothek.

Annunciation, 1658-60; oil on canvas, 45x38; Alte Pinakothek.

NEW YORK (UNITED STATES)
Midas at the Source of the River Pactolus, c. 1626; oil on canvas, 97.5x72.5; Metropolitan Museum of Art.

The Rape of the Sabines, c. 1634; oil on canvas, 154x206; Metropolitan Museum of Art.

PARIS (FRANCE)
The Triumph of Flora, c. 1627; oil on canvas, 165x241; Louvre.

Echo and Narcissus, c. 1627; oil on canvas, 74x100; Louvre.

The Plague of Azoth, 1630-31; oil on canvas, 148x198; Louvre.

The Triumph of Pan, 1634-37; oil on canvas, 138x157; Louvre.

The Rape of the Sabines, 1637-38; oil on canvas, 159x206; Louvre.

Moses in the Bulrushes, 1638; oil on canvas, 93x120; Louvre.

The Fall of Manna, 1637-38; oil on canvas, 149x200; Louvre.

Time Revealing Truth, 1641; oil on canvas, Ø 297; Louvre.

Ecstasy of St Paul, 1649-50; oil on canvas, 148x120; Louvre.

Rebecca at the Well, 1648; oil on canvas, 118x197; Louvre.

Landscape with Diogenes, 1648; oil on canvas, 160x221; Louvre.

The Judgment of Solomon, 1649; oil on canvas; 100x150; Louvre.

Self-Portrait, 1650; oil on canvas, 98x74; Louvre.

Landscape with Orpheus and Eurydice, 1649-50; oil on canvas, 120x200; Louvre.

The Death of Sapphira, 1654-56; oil on canvas, 122x199; Louvre.

The Four Seasons, 1660-64; oil on canvas, 118x160 (4 canvases); Louvre.

Apollo and Daphne, 1664; oil on canvas, 155x200; Louvre.

ROME (ITALY)
The Martyrdom of St Erasmus, 1628-29; oil on canvas, 320x186; Pinacoteca Vaticana.

PHILADELPHIA (UNITED STATES)
The Triumph of Neptune, 1634-37; oil on panel, 108x148; Philadelphia Museum of Art.

ST PETERSBURG (RUSSIA)
Tancredi and Erminia, 1630-31; oil on canvas, 98x147; Hermitage.

Landscape with Polyphemus, 1649; oil on canvas, 98x147; Hermitage.

Moses Striking the Rock, 1649; oil on canvas, 122.5x193; Hermitage.

Esther Before Ahasuerus, c. 1655; oil on canvas, 119x155; Hermitage.

TURIN (ITALY)
St Margaret, 1636-37; oil on canvas, 220x145; Galleria Sabauda.

VIENNA (AUSTRIA)
The Conquest of Jerusalem, 1636-38; oil on canvas, 147x198.5; Kunsthistorisches Museum.

WASHINGTON (UNITED STATES)
The Seven Sacraments: Baptism, 1642; oil on canvas, 95.5x121; National Gallery of Art.

BIBLIOGRAPHY

Following are some references for information about the artist. For a complete review of studies to date, we advise consultation of the bibliography in the catalogue edited by Denis Mahon for the Rome exhibition, *Nicolas Poussin. I primi anni romani*, Milan 1998.

1672 G.P. Bellori, *Le vite de' pittori, scultori et architetti moderni*, Rome

R. Fréart de Chambray, *Idée de la perfection de la peinture*, Paris

1685 A. Félibien, *Entretiens sur les vies et les ouvrages des plus excellents peintres anciens et modernes*, Paris

1914 Q. Grautoff, *Nicolas Poussin*, Munich

1934 G.B. Passeri, *Vite de' pittori, scultori et architetti che hanno lavorato in Roma morti dal 1641 al 1673*, Rome 1772

1960 A. Blunt (ed.), *Nicolas Poussin*, Paris

1964 N. Poussin, *Lettres et propos sur l'art*, collected and presented by A. Blunt, Paris

1967 A. Blunt, *Nicolas Poussin*, New York

1974 J. Thuillier, *L'opera completa di Poussin*, Milan

1978 P. Rosenberg, J. Thuillier, A. Blunt, *Nicolas Poussin 1594-1665*, Düsseldorf

1991 M. Marini, *Poussin*, in *Art Dossier* no. 54

1994 J. Thuillier, *Nicolas Poussin*, Paris

Y. Zolotov, N. Serebrannaïa, *Nicolas Poussin, Russian Museum Collections*, Bournemouth-St Petersburg

1998 D. Mahon (ed.), *Nicolas Poussin. I primi anni romani*, Milan

one hundred
paintings

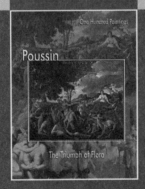